SIGHTS OF FAITH

The Cross and Clouds

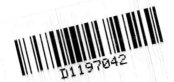

AMY BRETALL

Sights of Faith - The Cross and Clouds
Copyright © 2021 Amy Bretall
All rights reserved.
Published by Arbor Grove
LiveBreatheAlive.com

Paperback ISBN-13: Hardcover ISBN-13:
978-1-7358226-2-4 978-1-7358226-3-1

No part of this book may be reproduced or transmitted in any form or by any means, electronic or mechanical, including photocopying, recording, or any information storage and retrieval system, without permission in writing from the author.

THE HOLY BIBLE, NEW INTERNATIONAL VERSION®, NIV® Copyright © 1973, 1978, 1984, 2011 by Biblica, Inc.™ Used by permission. All rights reserved worldwide.

Scripture quotations marked (AMP) taken from the Amplified® Bible, Copyright © 2015 by The Lockman Foundation. Used by permission.

Scripture quotations marked (NASB) are taken from New American Standard Bible®, Copyright © 1960, 1971, 1977, 1995, 2020 by The Lockman Foundation. All rights reserved.

Scripture quotations marked (TLB) are taken from The Living Bible copyright © 1971. Used by permission of Tyndale House Publishers, Carol Stream, Illinois 60188. All rights reserved.

Scripture quotations marked (LASB) are taken from The Life Application Study Bible copyright © 1991. Used by permission of Tyndale House Publishers, Carol Stream, Illinois 60188. All rights reserved.

Scripture quotations marked (NRSV) are taken from The New Revised Standard Version Bible, copyright © 1989 the Division of Christian Education of the National Council of the Churches of Christ in the United States of America. Used by permission. All rights reserved.

Scripture quotations taken from the 21st Century King James Version®, (KJV) copyright © 1994. Used by permission of Deuel Enterprises, Inc., Gary, SD 57237. All rights reserved.

Printed in the United States of America

Dedication

To my adopted grandmother and dear friend Jean Mullins.
For having faith in me.

My Sweet Jean
1926 — 2016

Table of Contents

Amy Bretall

Introduction

Okay God, You have my attention.

I didn't plan on doing this book, but a pattern emerged in my phone's photo library. Isn't God great? Listening to the nudge, without knowing, I had been doing: capturing photos of unique crosses with what I considered amazing clouds and sky formations. For five years. And once I decided to make them into a book, I needed a handful more and found myself presented with more majestic sights of faith featuring The Cross and clouds.

I don't spend time waiting for the clouds to come along as an idyllic backdrop. Rather, they speak to me during my normal course of daily life: business, visiting family, and going on errands. I'd glance and see a cross framed with cloud formations in the majestic sky and had to stop to take a photo.

Just passing by, at *this* time, *this* day, the clouds called to me. So I listened.

The clouds move me. The movement, the set-up for a backdrop with a cross all pointing to the grace from above. A soft voice spoke. Yes, I see Lord.

It's God's timing. Cloud formed and timed, dissipating in seconds. Moving in minutes. Here and then gone. Will you take the shot? All it takes is looking up. The belief in God's all-knowing goodness.

This book is for people to see, experience, and know God's ways. To see God in our everyday life and connect to our natural surroundings is a continued extension of my first book *In Plain Sight: Faith Is In The Everyday*. The images in this book highlight the beauty of clouds, providing a certainty of faith to see what is placed before us. *Sights of Faith*.

This book is about a deeper relationship with God. Notes to and from. Words of my devotion, life, and love. It's what I've prayed and what I've received. It's a commitment to faith and a belief in faith. Introducing the spiritual significance of clouds and Biblical meaning, the scriptures of clouds are included along with the tests of faith God presents-- the grand plans from the architect above. Timed just right, as God always does.

My Love

Cookeville, Tennessee | 2021

I'm not going to give what hurts you.

Don't you see this?

Why do you keep trying, My child?

That wish is not My command.

You deserve what I give.

Your heart is aligned to Me.

We are together.

You pray for bigger and better things.

You've shown I'm the One; the first in your life.

My love, I will.

The River Community Church, non-denominational
Cloud Type: Cirrus

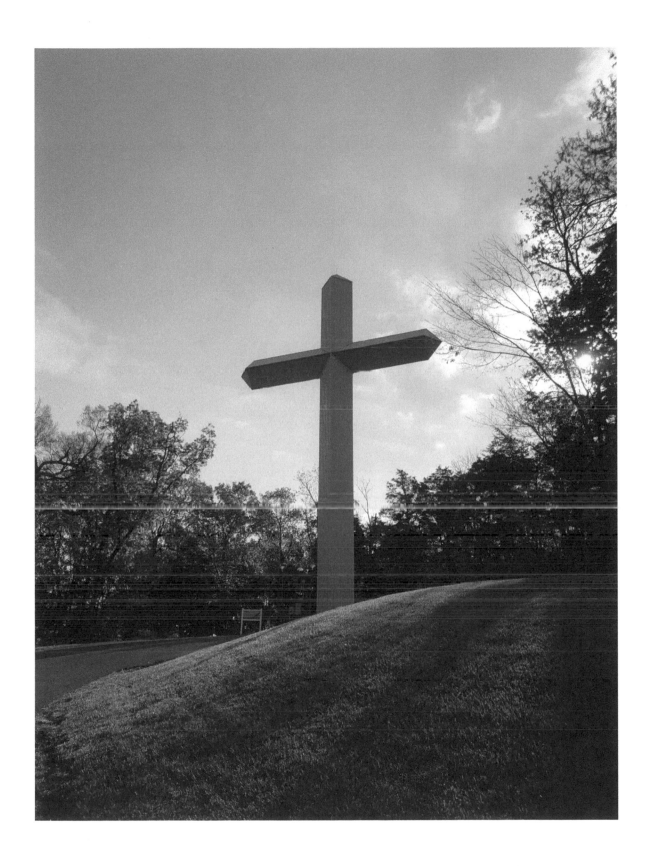

Look To The Cross

Victoria, Kansas | 2016

Lay low and rest.

I'm always here even when you feel I've faded away.

There are times you need to have patience and learn to trust Me.

Ease your mind and halt the worry. It's worn on you.

Always in a hurry and ready to go somewhere. Let the time of silence filter in and fill your space. Wait for Me.

When you need more, look around. Remember when I've shown up in your life.

Will you wait in stillness?

Take up your cross and look to Me.

Give your worries to Me. I'll take the load and carry more — just give them up.

I'm gentle in my ways. It's not in your control. So just, let. Let it be. Let it alone and surrender. Let Me.

In exchange you will receive ease. Ease of mind. Ease of spirit.

Take up your cross and look to Me.

Cloud Type: Cirrus

Amy Bretall

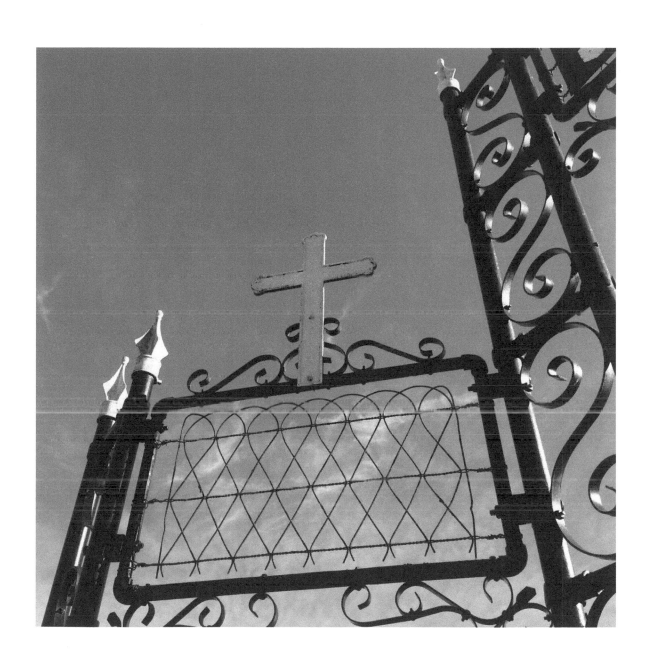

You Renew

Gatlinburg, Tennessee | 2021

Look up and see the glory.

Magnified intensity with the orchestrated exclamation of color and clouds.

How can we not see what You've placed before us?

Align our sight to your architecture above.

Knowing it's Your plan and design are The Way.

Keep looking up and keep the faith.

May You line our sight.

You renew.

Saint Mary's Catholic Church
Cloud Type: Cumulus
Subtype: Cumulus fractus

Let Us Behold

Kansas City, Missouri | 2021

Lord, let us behold.

What You show in Your almighty grace.

What You give in Your all-knowing ways.

May we trust in Your greatness and goodness.

Let us behold You.

It's not foretold for us to control the way. We think we can, but You place the pieces.

May we collect the signs, plant the seeds of faith, and harvest Your bounty.

If only we would. Then You could.

Let us behold.

Greek Orthodox Church of the Annunciation
Cloud Type: Altocumulus
Subtype: Altocumulus floccus

Amy Bretall

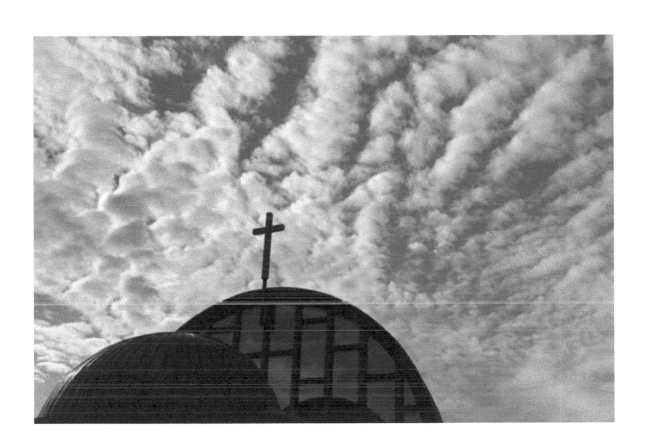

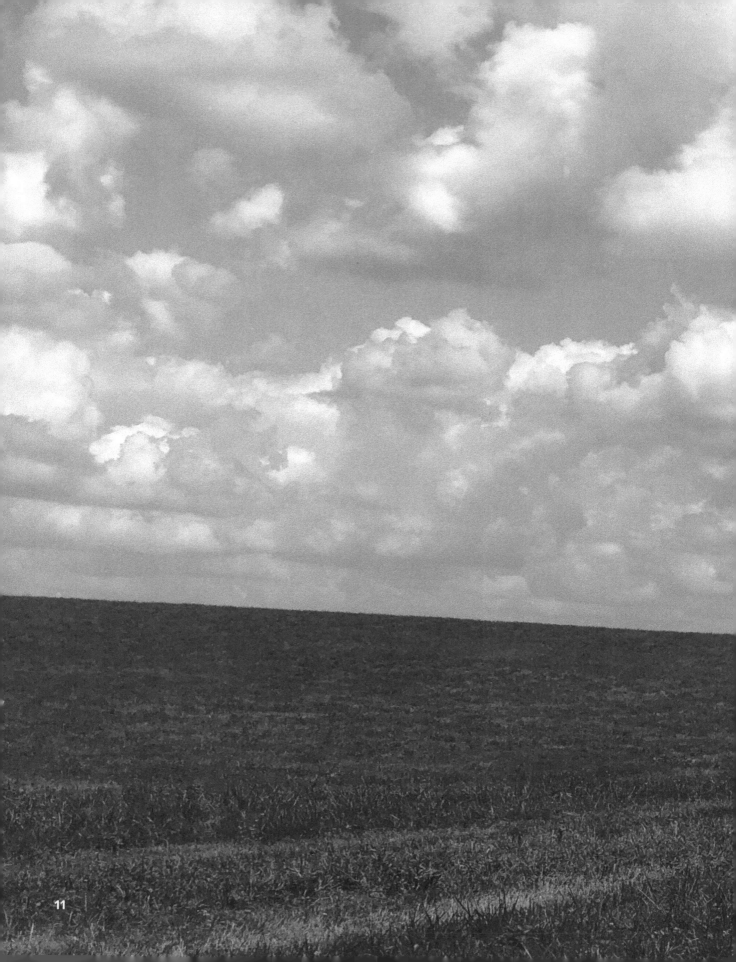

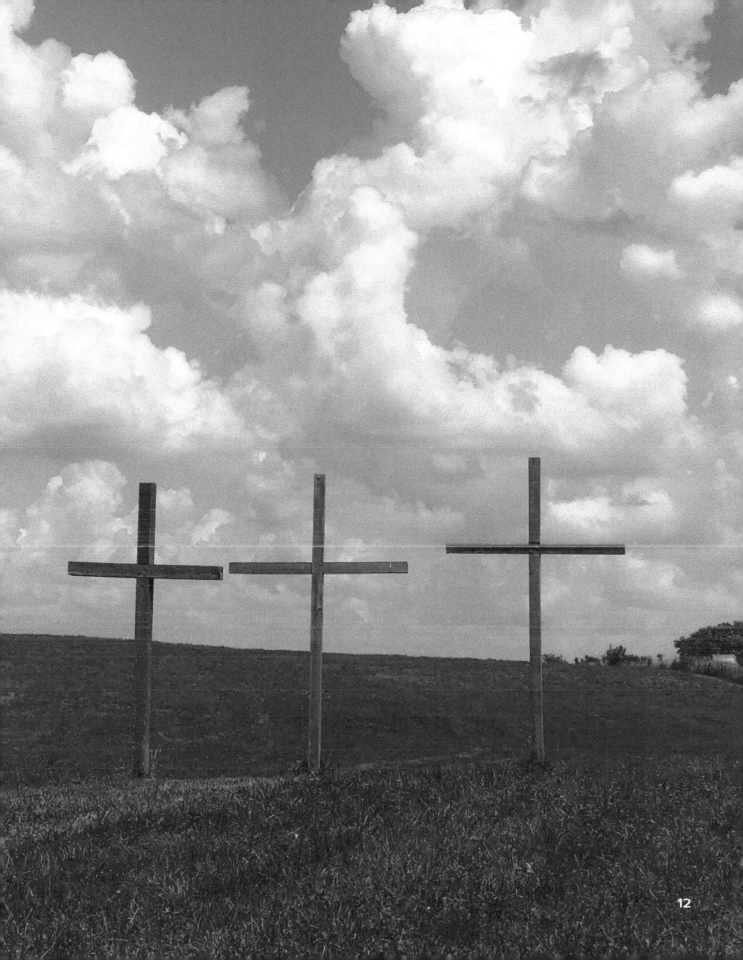

Don't You Know?

Brighton, Missouri | 2019

Don't you know how special you are?

I didn't make you to be like the others.

Your beauty doesn't compare.

I placed you at this time to see Me. To know Me.

Please, hear Me.

I placed things in you. It is for you to do.

I called you. Not someone else.

What others do is not for you.

I know you hear Me.

I see it in the ways you look for Me.

I know it in the ways you are for Me.

You hear Me.

Photo on prior pages 11/12: Chandler Baptist Church, Liberty Missouri
Cloud Type: Cumulus humilis
Subtype: Cumulus congestus

Fender Chapel, Baptist
Cloud Type: Cumulus
Subtype: Cumulus humilis

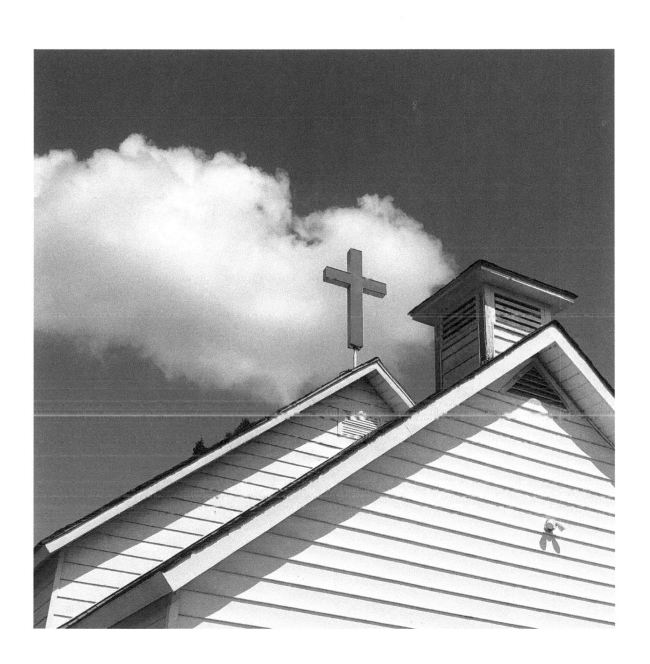

Lay Down Your Cross

Sikeston, Missouri | 2021

Let it go. Let it down.

Your guard, your grief.

Replace it with love. It's warm in here — your heart.

Let go of the cold, the ache, the pain.

Come to Me and lay it down.

Remember the good. Forgive the rest.

Let Me fill you with love.

Love feels so much better. It warms and multiplies.

Come to Me and lay down your Cross.

Church on the Rock, non-denominational
Cloud Type: Cumulus
Subtype: Stratocumulus castellanus

Amy Bretall

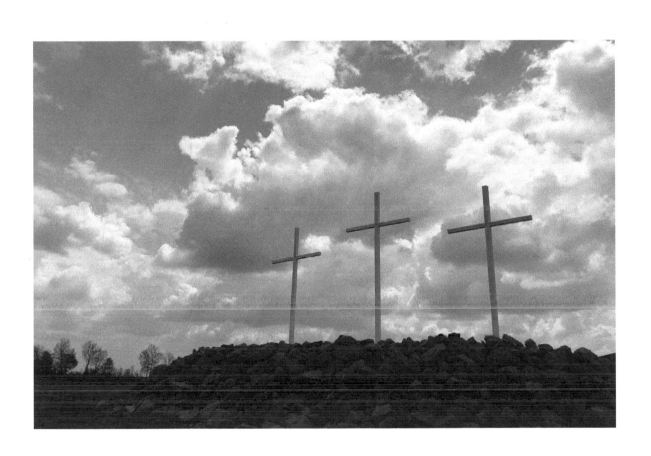

Scripture

Guiding. Direction
"By day the Lord went ahead of them in a pillar of cloud to guide them on their way and by night in a pillar of fire to give them light, so that they could travel by day and by night. Neither the pillar of cloud by day nor the pillar of fire by night left its place in front of the people."
- Exodus 13:21-22

Power. Love
"At the morning watch, the Lord looked down on the army of the Egyptians through the pillar of fire and cloud and brought the army of the Egyptians into confusion."
- Exodus 14:24 NASB

Guidance
"On the day the tabernacle was set up, the cloud covered the tabernacle, the tent of the testimony, and it appeared like fire above the tabernacle from evening until morning."
- Numbers 9:15 LASB

Power. Patience
"Go up now, look toward the sea." So he went up and looked and said, "There is nothing." And he said, "Go back" seven times. It came about at the seventh time, that he said, "Behold, a cloud as small as a man's hand is coming up from the sea." And he said, "Go up, say to Ahab, 'Prepare your chariot and go down, so that the heavy shower does not stop you.'" In a little while the sky grew black with clouds and wind, and there was a heavy shower. And Ahab rode and went to Jezreel."
- 1 Kings 18:43-45

Photo: Victoria, Kansas 2016
Cloud Type: Cirrus
Subtype: Cirrocumulus stratiformis

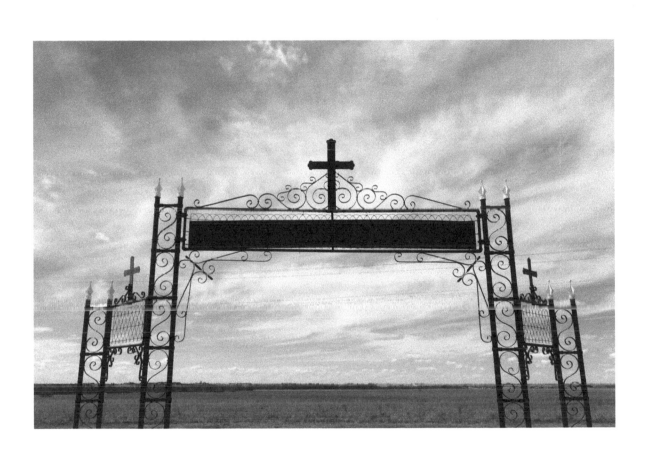

I Will

Victoria, Kansas | 2016

You told me to follow and I finally did. It only took me a few years.

My own will, my own way, had to be broken in order do this for You.

You told me again and I will. I am.

I've learned to trust You even when it doesn't fit into this worldly way.

I'm living for something more.

I'm doing this for You.

Prior Pages 19/20, Victoria Kansas, Cloud Type: Cirrus (top) / Cumulus (bottom)
Subtype: Cirrus fibratus duplicatus / Cumulus fractus
Cloud Type: Cirrus
Subtype: Cirrostratus

Amy Bretall

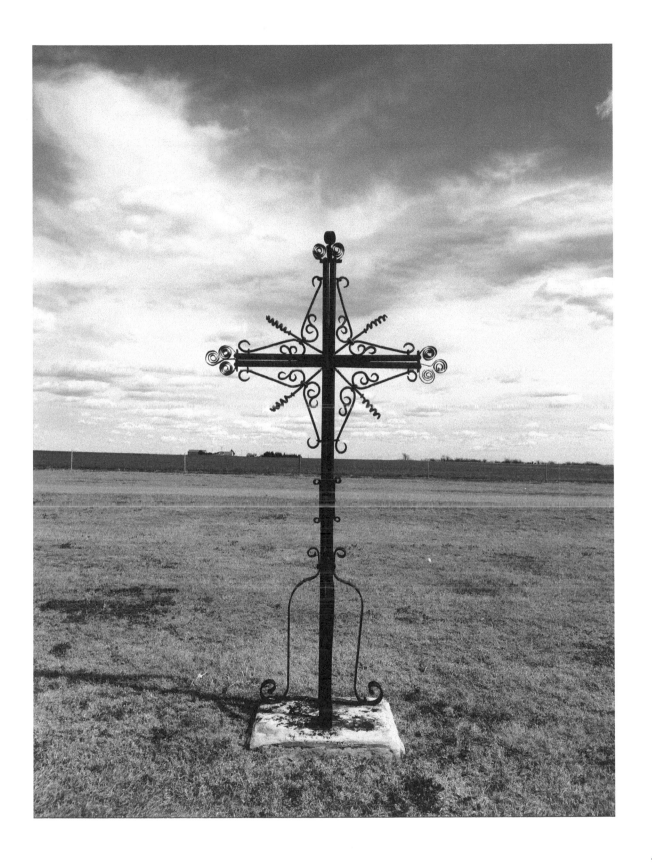

You Are Chosen

Belton, Missouri | 2021

You are chosen.

Not to be made to jump through hoops, to do more, to show more, over and over.

Not to be made to prove—your love or your worth.

You are chosen.

You are proven.

You are worthy of The One. And once you know, and trust this stamp of approval, you won't try to measure up to someone's sliding scale.

The test of time is given. Time slips in human concept, but expands with eternal sight.

You have been chosen by Me. And that is all you need.

El-Bethel Baptist Church
Cloud Type: Cirrostratus
Subtype: Cumulus congestus

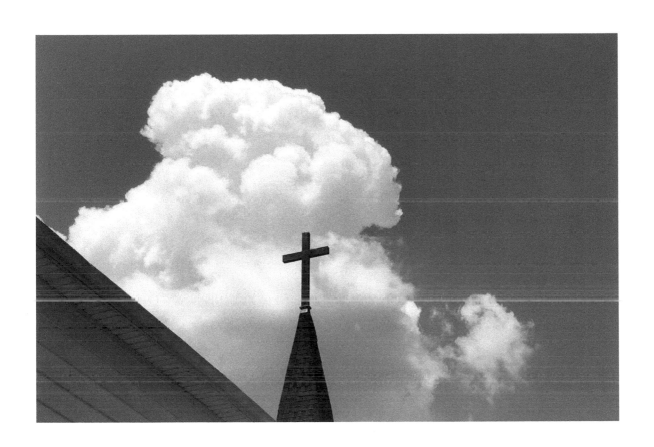

More

Oklahoma City, Oklahoma | 2018

More.

That's what I'm going to get in this life.

More of Your good love.

More of what You have in store.

More of what I can do for You.

More of the good. More of what makes me alive —it's following what You've placed in my heart.

You lead. I'll follow.

I want more of You.

First Church, Methodist
Cloud Type: Cirrus
Subtype: Cirrus fibratus intortus

Photo on page 27, Victoria Kansas 2016
Cloud Type: Cirrus
Subtype: Cirrus spissatus

Photo on page 28, Visitation Catholic Church, Kansas City, Missouri 2016
Cloud Type: Cumulus
Subtype: Cumulus fractus

Amy Bretall

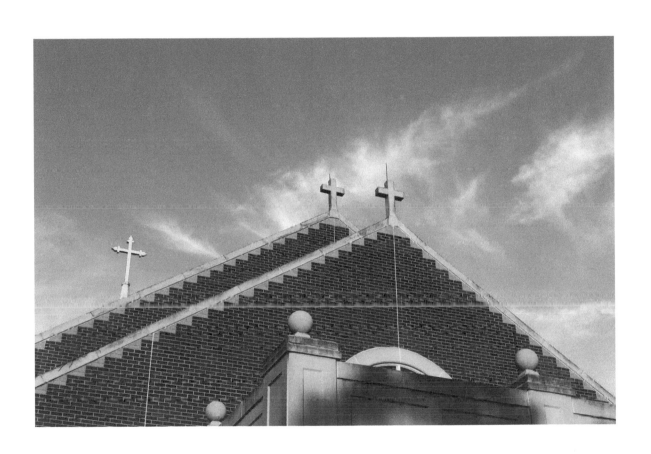

Sights of Faith

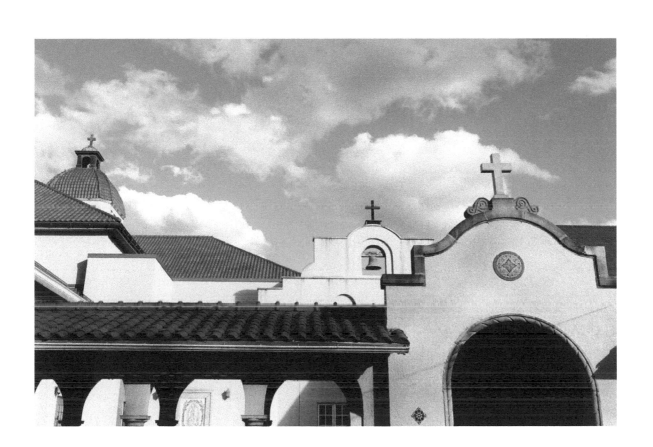

I Was the Fig Tree

Belton, Missouri | 2019

I was the fig tree.

And needed one more year.

To grow and be fruitful. To realize my planting.

Maturing the strength of my own beliefs.

"Don't give up on me." God never does.

We give up on ourselves; letting that little voice whither.

"What could I do if I really believed?"

There's no one else to do it. "I gave it to you."

Water your roots of faith.

Lift your arms in gratitude.

Kneel on the leaves of prayer.

Believe in your planting.

The fig tree of faith will harvest.

First Baptist Church of Belton
Cloud Type: Cirrus (top), Cumulus (bottom)
Subtype: Cirrus spissatus, Cumulus humulis

Amy Bretall

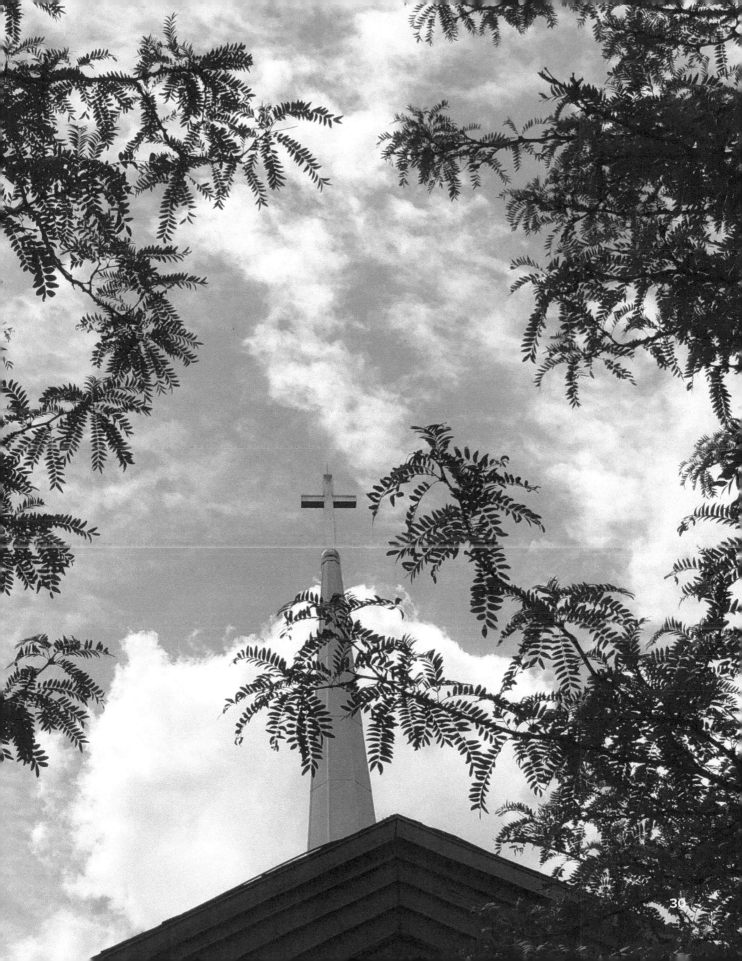

The Order of One

Tipton, Missouri | 2020

You take my breath away.

Coming out of nowhere with power and grace.

Drawing my eye to You.

Your love doesn't compare in human form.

You mean it when You say to put Me first because this love multiplies.

Without compare You are a love of life. Love to life.

A relationship developed in time devotion and everlasting certainty.

First place.

The order of one. The One to order our steps.

It just keeps getting better.

Loving faith. A faithful love. The order is one.

Tipton Methodist Church
Cloud Type: Cumulus
Subtype: Cumulus fractus

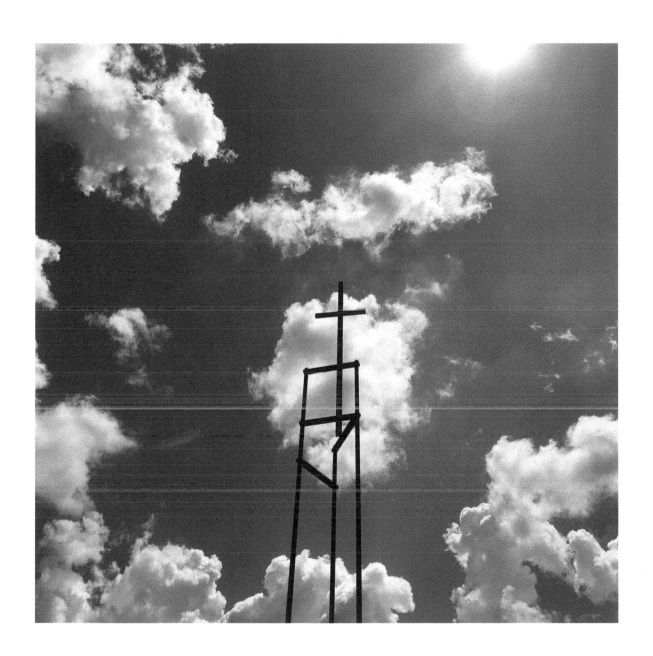

Soul Hole

Indianapolis, Indiana | 2018

I feel a hole.

One that doesn't fill.

Some try to fill it with things, but it's not that kind of place.

In the hole I planted people, a love.

It feels empty when the bulb is pulled.

A love removed, taken too soon.

That's because it's a soul hole.

It's deeper.

You watered it and grew the space.

Roots gave meaning.

Planned on good things to sprout.

A loving birth.

But the hole is now empty.

A tree isn't always in a grove.

The hole you have is yours to fill.

It's not easy when the filling was shared.

Seasons of time churn the ground.

Turn the soil with prayer.

A harvest of faith will bring fullness.

It's yours to find.

It's faith to fill.

St. John the Evangelist Catholic Church

Cloud Type: Stratus

Subtype: Stratocumulus stratiformis opacus

Amy Bretall

Reach Out to Me

Edmond, Oklahoma | 2018

Stretch out your arms and embrace My love.

Don't you know I'm always here. In big and small ways, I'm watching out for you.

I'm always close even when events take you away — when you let other priorities get in the way. Reach out to Me.

Let Me get in the way for once.

Let Me be your go-to.

Let Me be your first call.

Let Me be "The One."

Reach up to Me. Stand tall knowing My strength is here for you.

Reach out to Me.

Life Church, non-denominational

Cloud Type: Stratus

Subtype: Stratocumulus stratiformis opacus

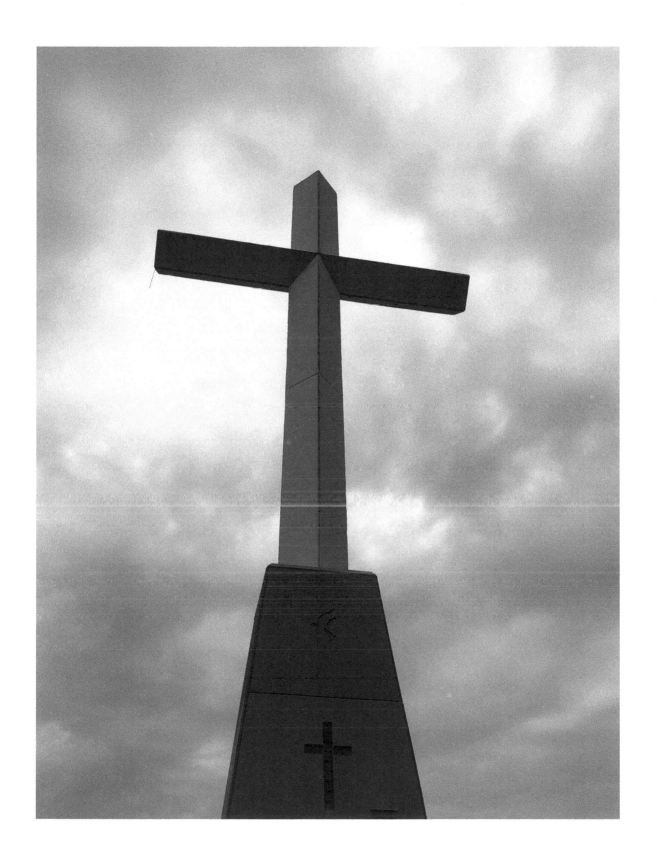

Love From Above

Prairie Village, Kansas | 2019

Who can say no?

To Your grace and beauty. Your soft love absorbing our soul holes. Soaking in and soaking up, Your loving goodness flows.

If we only let the love be received. Know the love is ours to have.

It's often easier to show love to others than ourselves. The striving, the to-do list, taskmaster in the mind. Give me, myself, and I a break.

Accept the soft grace of love from above. Soak it in. Share the love with yourself.

Surround yourself within the grace of good self-talk. Even with set-backs, disappointments, and worldly life-fails. "Again?" may be asked.

Well, yes. Try it again. A new attempt. A new chance. Reframe your negatives and find the positives. See the good.

Say "Yes" to the love from above.

Saint Ann's Catholic Church
Cloud Type: Stratocumulus
Subtype: Stratocumuls floccus

Amy Bretall

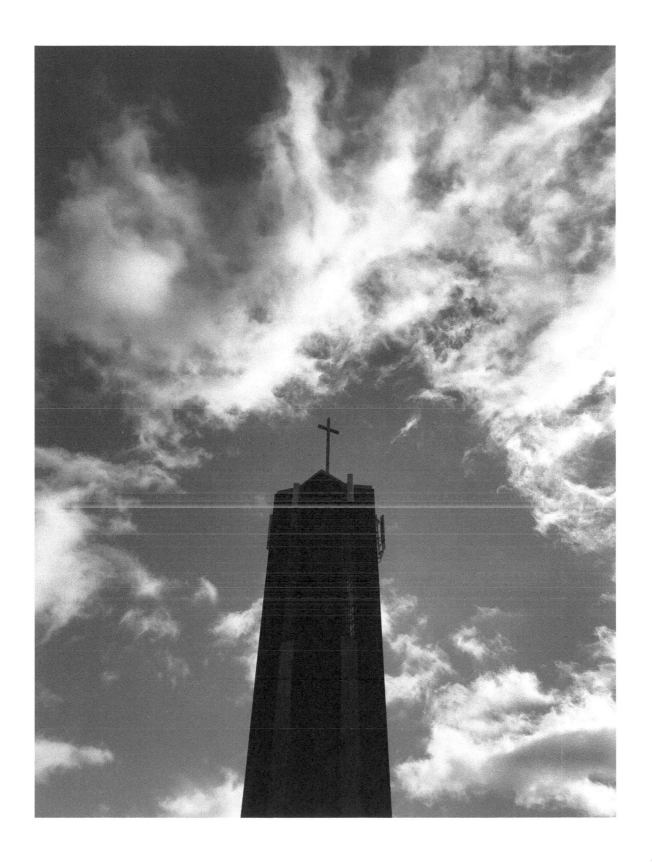

You Move In

Havana, Cuba | 2016

You move in and around at the right time.

Providing a space to fill my need.

So graceful and smooth, You glide.

Providing comfort when I can't go any more.

You move in, forming right in front of my focus.

A pace of ease affirming The Great Comforter.

This timely movement is a warm embrace.

Your movements from above.

Note: This is the one photo in the book that doesn't include a cross. It grabbed my attention with the marvelous clouds and timing. Ahead I saw an opening, just one minute for the clouds to pass behind this statute. Behold.

Cloud Type: Cumulus
Subtype: Cumulus fractus

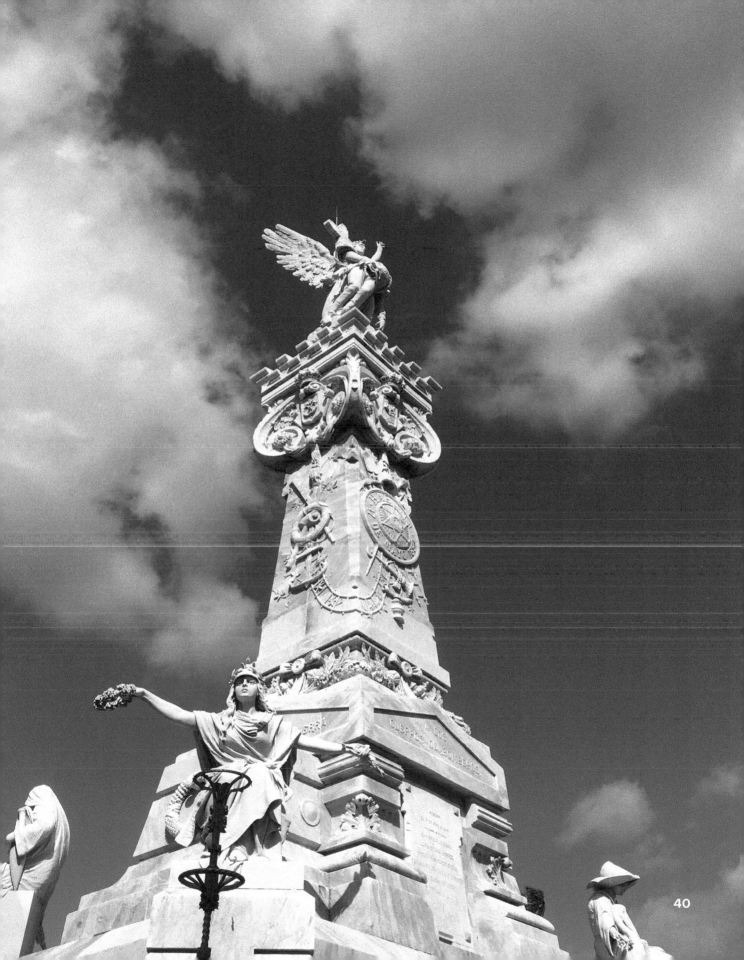

I Am Here

Kansas City, Missouri | 2019

I see that you know the way.

I've watched the steps you've taken.

I heard you answer My call.

You followed My voice even when you didn't understand.

You showed Me honor.

You trusted My words.

In the hard times, the choices that tested your faith, you trusted
Me.

It's not for anyone else to know your call.

It's a relationship of you and I.

Others won't get it. It's not for them to know.

It's for Us.

You have been there when I called.

I Am here.

Redemptorist Catholic Church

Cloud Type: Cumulus

Subtype: Cumulus humulis

Amy Bretall

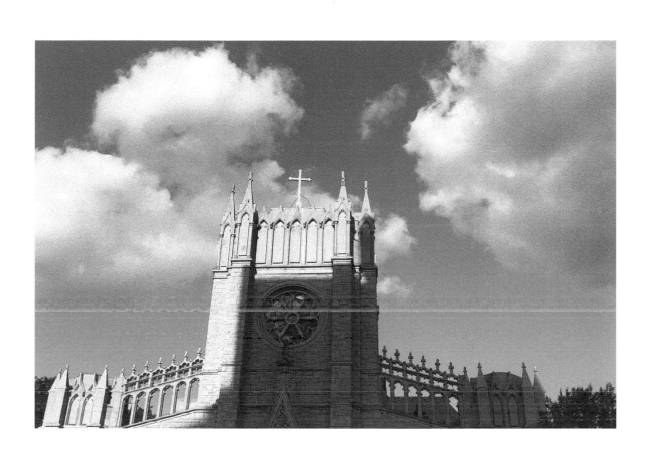

Sights of Faith

Spiritual Significance of Clouds

The Bible contains over 80 individual verses with the word cloud, clouds, or cloudy: 85 percent in the Old Testament and 15 percent in the New Testament. Since the Old Testament comprises roughly 67 percent of the Bible and the New Testament 33 percent, there is a close balance of representation of cloud scriptures between the two.

Throughout the Bible, clouds are presented as symbols to represent God's presence, strength, direction, hope, praise, the coming of Christ's return, protection, power, knowledge, and assurance. Additionally, clouds are utilized to illustrate themes and nature's goodness, including the divine lifecycle of rain, produced by the clouds, for water to replenish, hydrate, and nourish. Rain for harvest was especially important as farming was a principal occupation. In God's all provident knowledge, he fulfilled the ongoing cycle for life with clouds bringing rain and providing shade from the heat. Evidence of God is found in the clouds as a form of nature.

The meaning of clouds in the Bible is spiritually significant with scriptures and stories illustrating God's power. Starting in the first book in the Bible, Genesis, clouds are utilized in the flood narrative. Stepping off the Ark, Noah received a symbol of life in the rainbow and clouds.

> *"I have set my rainbow in the clouds, and it will be the sign of the covenant between me and the earth. Whenever I bring clouds over the earth and the rainbow appears in the clouds,"*
> *Genesis 9:13-14*

One of the most noteworthy and well-known biblical stories of clouds is with Elijah in 1 Kings. The story: The land desperately needed rain due to a three-year drought and severe famine. Elijah was a prophet living in Israel during the reign of King Ahab and defended the worship of God over the Cannanite false god Baal. The people and King Ahab abandoned God and were oscillating between worshipping God and Baal. Meeting on Mount Carmel, Elijah asked the people, "How long will you waver between two opinions? If the Lord is God, follow him; but if Baal is God, follow him." 1 Kings 18: 21.

Elijah was steadfast in his belief of God. He said to the people, let's have a test and find out: in essence, have a stand-off and prove the real God. The 450 people worshipping

Baal, and me of one worshipping God. Let's provide a sacrifice and you call out to Baal to light the fire. "Then you call on the name of your god, and I will call on the name of the Lord. The god who answers by fire—he is God." 1 Kings 24

The people called on the name of Baal from morning to noon but there was no response. Elijah encouraged them to shout louder, so they did until the evening, but still there was no response. Then Elijah called the people to prepare a sacrifice and they did, but still no response. Then Elijah prayed to God, believing in God's instructions, and fire came. The people cried and said, "The Lord—he is God!" Elijah said to King Ahab, "Go, eat and drink, for there is the sound of a heavy rain."

"Go and look toward the sea," he told his servant. And he went up and looked. "There is nothing there," he said. Seven times Elijah said, "Go back." The seventh time the servant reported, "A cloud as small as a man's hand is rising from the sea." So Elijah said, "Go and tell Ahab, 'Hitch up your chariot and go down before the rain stops you.'" Meanwhile, the sky grew black with clouds, the wind rose, a heavy rain started falling and Ahab rode off to Jezreel." 1 Kings 18:43-45

The takeaways: First, from *Matthew Henry's Concise Commentary,* great blessings often arise from small beginnings. In this scripture story it's a big downpour of rain coming from a small cloud in the distance. When we see God moving in even small ways among us, we should have faith for a greater work to come. Secondly, Elijah was patience and persistent in prayer. He was expecting an answer and did not stop praying. It was not just one time he prayed for rain, nor twice, but seven times he prayed faithfully, with belief in his heart. Each time he sent his companion to check the horizon, coming back to report nothing was seen. Elijah was confident in God and kept praying. On the seventh time of prayer, the servant came back and reported "There is a cloud, as small as a man's hand, rising out of the sea!" Thirdly, Elijah showed his steady, steadfast belief in God, and God alone. His patience and perseverance were rewarded.

Clouds illustrate guidance and direction, with the wording "pillar of cloud" signifying God's presence, and how he led the people through the wilderness.

"By day the Lord went ahead of them in a pillar of cloud to guide them on their way

Amy Bretall

and by night in a pillar of fire to give them light, so that they could travel by day or night. Neither the pillar of cloud by day nor the pillar of fire by night left its place in front of the people." Exodus 13:21-22

Guidance, along with power and love, are symbols of the clouds in the scriptures of God parting of the Red Sea at the right time to save and protect the people of Israel escaping slavery in Egypt.

"At the morning watch, the Lord looked down on the army of the Egyptians through the pillar of fire and cloud and brought the army of the Egyptians into confusion." Exodus 14:24

"God guided them by sending a cloud that moved along ahead of them; and he brought them safely through the waters of the Red Sea." 1 Corinthians 10:1, TLB

Clouds are a symbol of God's divine presence in Exodus when "the glory of the Lord" was manifested in a cloud.

"While Aaron was speaking to the whole Israelite community, they looked toward the desert, and there was the glory of the Lord appearing in the cloud." Exodus 16:10

Showing God's presence, clouds were a guiding force for Moses. The cloud filled the court around the tabernacle in the wilderness so that Moses could not enter it.

"Then the cloud covered the tent of meeting, and the glory of the Lord filled the tabernacle. Moses could not enter the tent of meeting because the cloud had settled on it, and the glory of the Lord filled the tabernacle. In all the travels of the Israelites, whenever the cloud lifted from above the tabernacle, they would set out; but if the cloud did not lift, they did not set out—until the day it lifted. So the cloud of the Lord was over the tabernacle by day, and fire was in the cloud by night, in the sight of all the Israelites during all their travels." Exodus 40:34-38

Continuing in the Old Testament, the book Job includes eight verses with the word cloud(s). The story: Job was a wealthy and good man with a large family. God tells Satan about Job's goodness, but Satan argues that Job is only good because God has blessed

him. Satan issues a challenge to God, that if Satan could punish him, then Job will turn his back on God. God accepts and permits Satan who afflicts pain to his wealth and his family, loss upon loss—to his livestock, his power in wealth, and death of his 10 children. Job mourns the losses, but still gives thanks to God in prayer. Satan asks again to test Job and God allows another chance. This time Satan inflicts severe pain to Job's own health with painful sores all over his body. His wife suggests cursing God and to give up. Wishing that he had never been born, four of Job's close friends all suggest, in some form and fashion, that all of this loss and pain is due to Job's failing other people, his own sins, or failing God in some way to produce such a result. Job rebukes his friends' accusations. Job considers and questions God's abundant knowledge. Clouds are used as symbols of power and divine knowledge when God asks Job:

> *"Can you raise your voice to the clouds and cover yourself with a flood of water?"*
> *Job 38:34*

> *"Do you know how God controls the clouds and makes his lightning flash? Do you know how the clouds hang poised, those wonders of him who has perfect knowledge?"*
> *Job 37:15-16*

Matthew Henry's Concise Commentary interprets this scripture that the best people "are much in the dark concerning the glorious perfections of the Divine nature. Those who, through grace, know much of God, know nothing." Job maintained his confidence in God and believed there was a witness in heaven who would vouch for his innocence. God came and spoke to Job asking how he knew His ways, asking if he was there here when creation began? The Lord was angry with Job's friends because they had not spoken the truth about God. Job prayed for his friends. And then God restored Job's fortunes and gave him twice as much as he had before. Job did not give up on God and would not be swayed even when his material possessions were taken. He did not turn from God, even when his friends gave him bad advice.

The book of Psalms has numerous references to clouds used to illustrate God. For example:

- Presence: "Out of the brightness of his presence clouds advanced" (18:12);
- Provision: "commanded the clouds from above" (78:23) whereby the people were fed with manna;
- As a Divine Warrior: "making the clouds His chariot" (104:3);
- Power: "He spread a cloud for a covering, and a fire to give light at night." (105:39);
- Praise: "He covers the sky with clouds; he supplies the earth with rain" (147:8);
- Holiness and Glory: "Clouds and thick darkness surround him" (97:2).

Reminding us not to worry, a verse in Ecclesiastes teaches us that there never is a perfect time; there will always be a reason not to do something. Don't worry if it doesn't work out. Don't worry about the clouds, the wind may take it away.

> *"He who watches the wind will not sow and he who looks at the clouds will not reap."*
> *Ecclesiastes 11:4*

In the New Testament, the scriptures of clouds contain imagery of God's presence and the power of the Holy Spirit. On the Mount of Transfiguration, "a bright cloud covered them, and a voice from the cloud said 'This is my Son, whom I love; with him I am well pleased. Listen to him." Matthew 17:5. The New Testament also features clouds as symbols of Christ's return described as, "coming in the clouds and the ascension into Heaven behind a cloud (Acts 1:9).

> *"Then will appear the sign of the Son of Man in heaven. And then all the peoples of the earth will mourn when they see the Son of Man coming on the clouds of heaven, with power and great glory." Matthew 24:30*

> *"At that time people will see the Son of Man coming in clouds with great power and glory." Mark 13:26*

> *"After that, we who are still alive and are left will be caught up together with them in the clouds to meet the Lord in the air. And so we will be with the Lord forever." 1 Thessalonians 4:17*

"After he said this, he was taken up before their very eyes, and a cloud hid him from their sight." Acts 1:9

In Revelation, the last book of the Bible, clouds are utilized for the second coming: "Look, he is coming with the clouds, and every eye will see him." (Rev 1:7). The last scripture in the Bible referencing a cloud is another placement illustration being "seated on the cloud" (Rev. 14:16).

My Call To The Clouds

Life's Weather Pattern
The ways of God are reflected in the clouds. As a blanket of love and comfort. Dotted clouds in pointed exclamations of abundance. A light touch of presence. The big boldness showing power. The rain clouds that hover too long, but the storms will pass. There may not be a beautiful sunlit white puffy cloud today, but know, it will come. In faith, and with God, there is certainty, there is hope.

While taking photos of crosses with clouds I've noticed several themes:

Timing/Guiding
There has been an inherent pull of clouds in my faith journey, as if the clouds are showing the way. Taking photos of crosses with clouds has been divine timing. Going about my daily activities, I glance a certain way, see beauty, and feel called to stop to take a photo at *this* time, *thi*s day. "Stop, see Me. Come closer. Trust Me. Let Me lead you." Okay God, I will. There is a holy intention to connect with nature, to take the time and look up. It's not just the mighty power in formation, but also a gift of grace. Clouds are a reminder of God's grace and goodness. In nature we are able to see sights of faith and see God's presence.

Majestic
Natural beauty shouting for joy. Cloud formations and coloring of the sky. Beaming down from above. Look up, see more than what is down there. Focus up here, lift your gaze, let Me show you what I can do. Do you see all of this?

Amy Bretall

Looking up to the sky with its unique coloring and clouds formations, I hear God say:

It's your moment, your time.
It's not given to anyone else but for you to see and do.
The openings, the abundance and provision.
It's divine timing for you to see.
Today. The here and the now.
Look up and see Me.

Behold: The Architect Above
Your Alignment. Your angle. Perspective matters. What are you allowing in your sight? And what do you allow to surround you? There is power in our angle of sight and being aligned with God. Even a simple "looking up" perspective can change your viewpoint.

An easy entrance to faith and spiritual relationship is the recognition to the creator, continued with a repeated gratitude for all the wonder that nature provides. Opening our eyes to what is all around us, every day, can deepen our faith. Like the clouds and sky, God is the architect above, in heaven and on earth. The Great Designer who plans ahead. It's up to us to acknowledge who is creating the pattern and decide if you will follow God's plan, or your own?

See appendix for cloud scriptures.

Stillness

Havana, Cuba | 2016

In the stillness I hear Your voice.

What sweetness You say to me when needed— good givings in my times of misgivings.

In the rays of light I see Your space.

A place of anywhere — You are all aware of right here and now.

Telling me to stay in the present. Keep your thoughts on today. Not yesterday. Not tomorrow.

Hold the focus on the beauty of this day.

Cloud Type: Cirrus

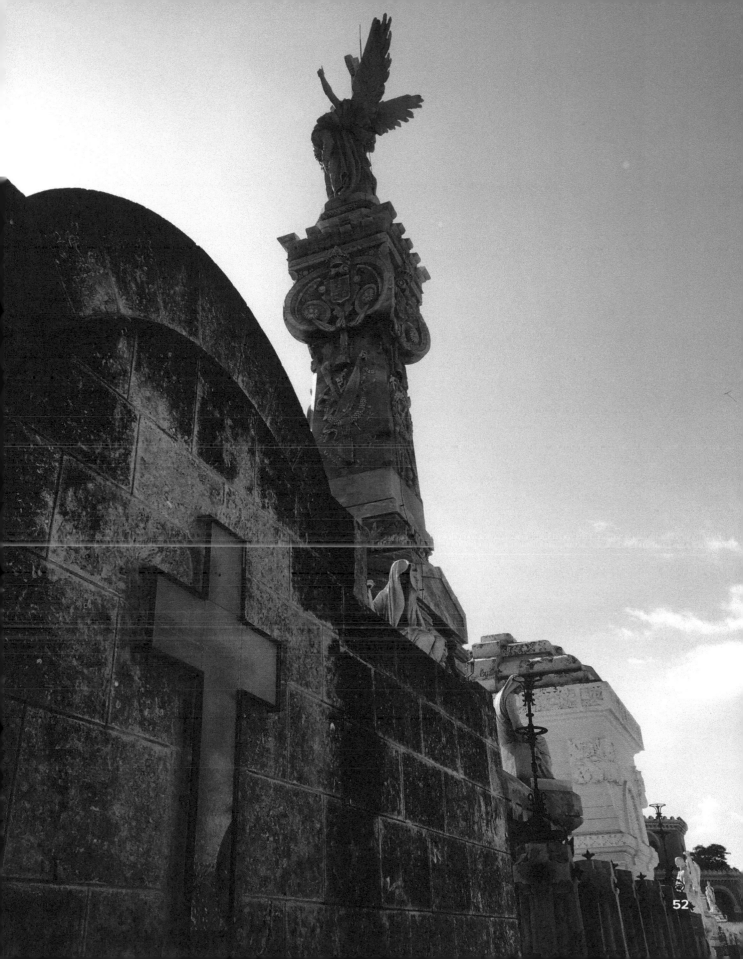

Scripture

Praise
*"He covers the sky with clouds; he supplies the earth with rain
and makes grass grow on the hills."*
- Psalms 147:8

Coming in the Clouds
*"Jesus said, 'I am; and you will see the Son of Man seated at
the right hand of Power (the Father), and coming
with the clouds of heaven."*
- Mark 14:62 AMP

Power of the Holy Spirit. Ascension
*"When he had said this, as they were watching, he was lifted up,
and a cloud took him out of their sight."*
- Acts 1:9 NRSV

Guidance
*"God guided them by sending a cloud that moved along
ahead of them; and he brought them safely through the
waters of the Red Sea."*
- 1 Corinthians 10:1 TLB

St. Teresa's Academy, Kansas City, Missouri 2016
Cloud Type: Cumulus
Subtype: Cumulus fractus

Amy Bretall

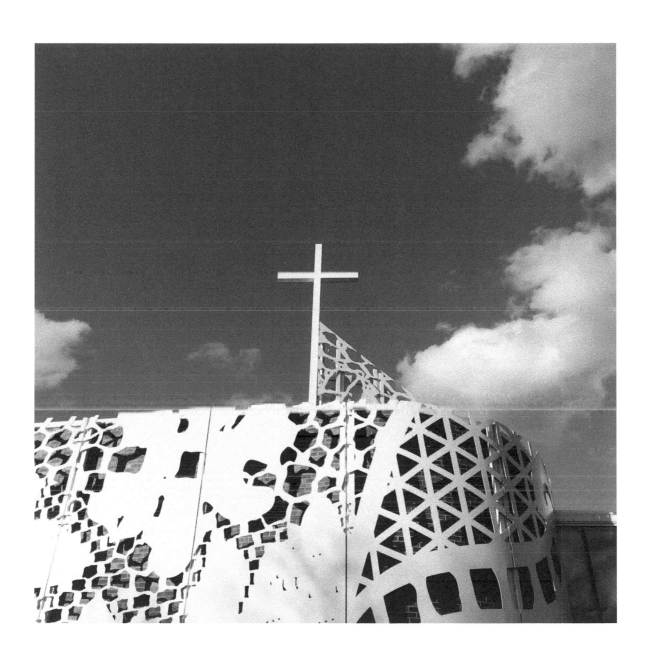

You Don't. And I Won't.

Tipton, Missouri | 2018

I did what You said so why aren't You giving me what I want?

We're on the same team here, God. I'm working for You.

My wants get in the way of Your way. I know this. It's a test.

One can go with the flow for quite a while, but then a choice has to be made. Will I be obedient to what I've learned, and who I am, or will I walk the worldly way of convenience?

It's an internal interruption that can't be calmed. Even when I want it to go away, it won't, because the heart and the spirit speak.

Not being authentic costs too much; I'm not willing to pay that price.

Faith values win.

I accept Your way. It has become mine too.

You don't. And I won't.

You don't give me what I want. And I won't compromise my faith beliefs.

Cowboy Church
Cloud Type: Cirrus
Subtype: Cirrus fibratus intortus

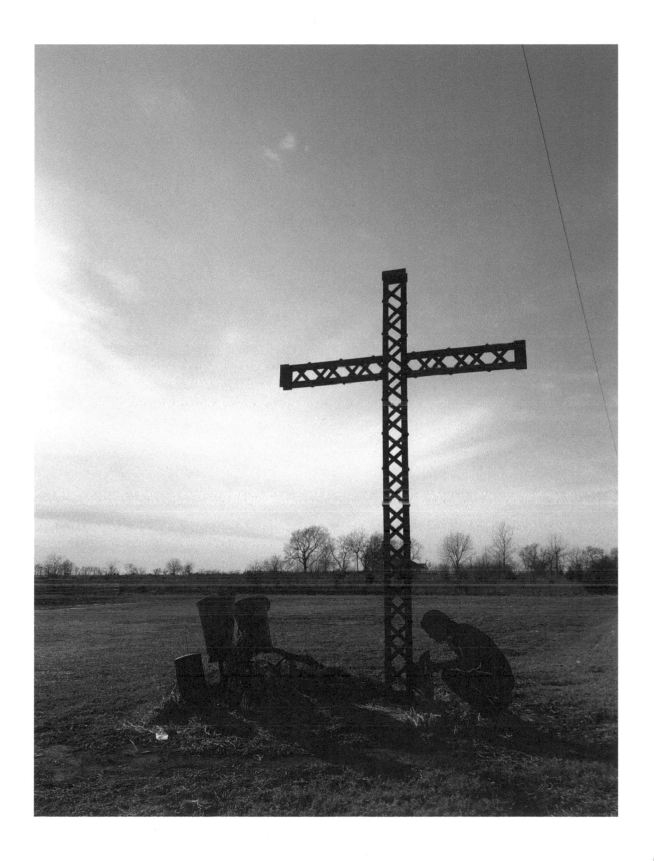

Your Cover

Tipton, Missouri | 2016

You cover with surrounding goodness.

Like a blanket, You are The Great Comforter.

Watching You roll in, showing a new day, a new sky, a new beginning.

Not to look back at what used to be a considered comfort.

Look up, look out and look ahead.

God is The Great Comforter.

St. Andrew's Catholic Church
Cloud Type: Cirrocumulus
Subtype: Cirrocumulus undulatus

Amy Bretall

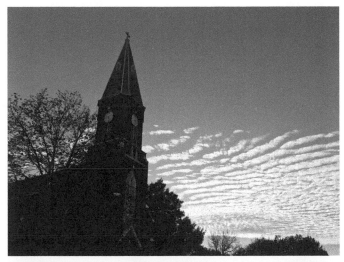

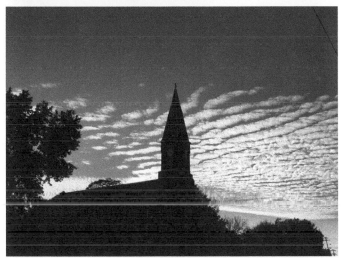

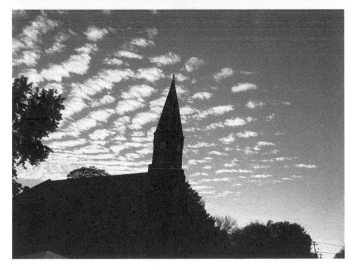

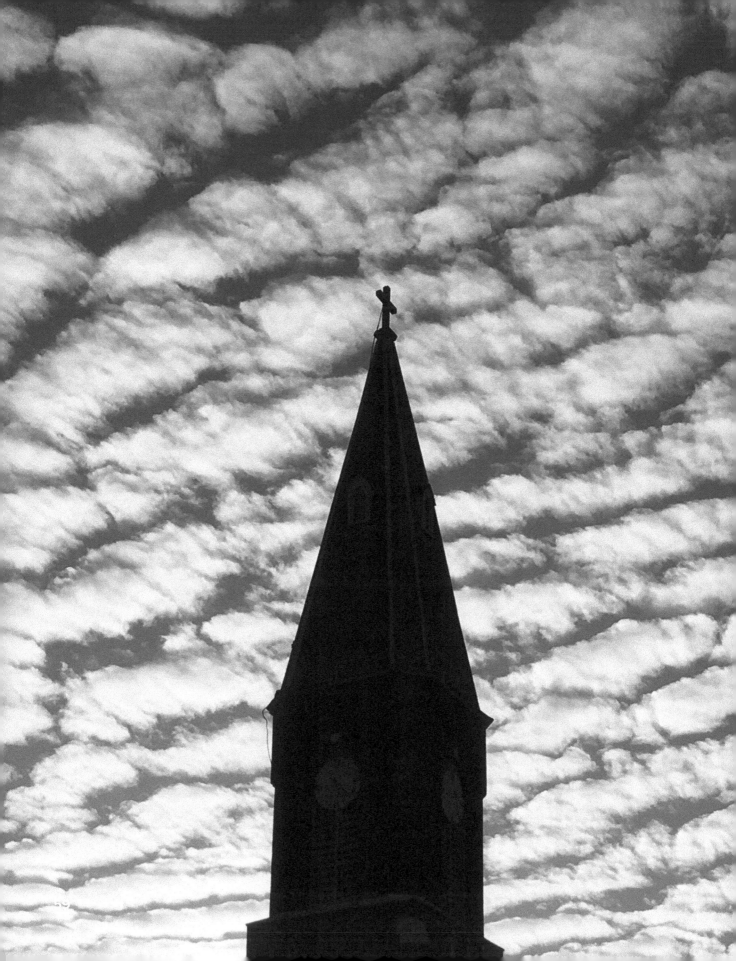

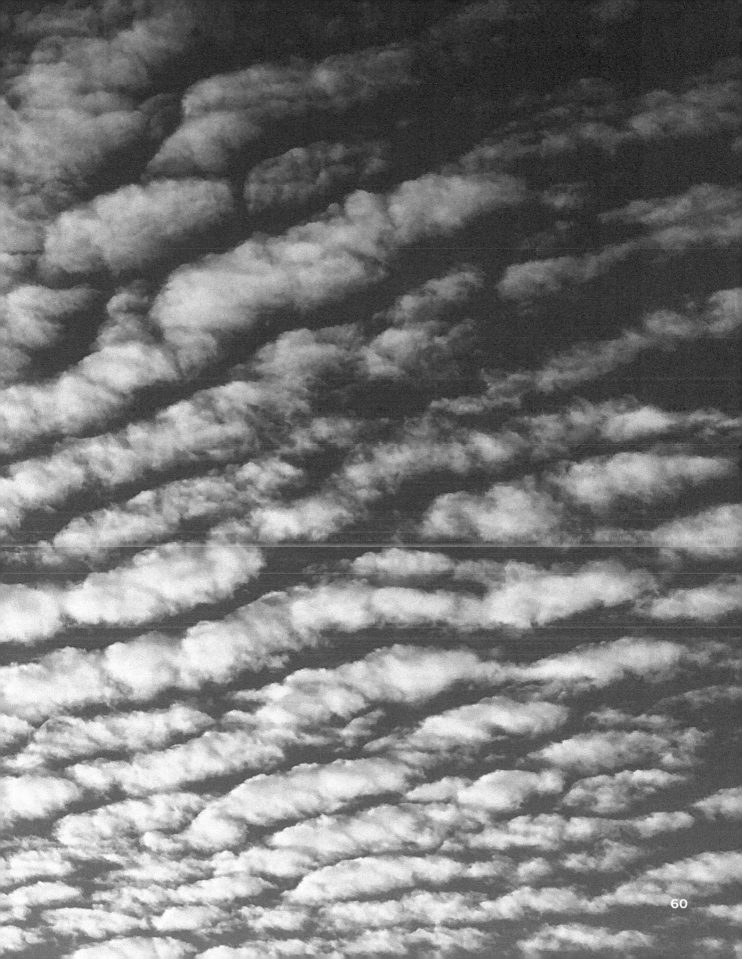

Show Me

Washington D.C. | 2017

I say you are more than enough.

To hold My love and be of love.

When it hurts, love more.

Show life Me.

You have more love.

Give back with love.

Show others Me.

Washington National Cathedral

Cloud Type: Cumulus

Subtype: Stratocumulus stratiformus opacus

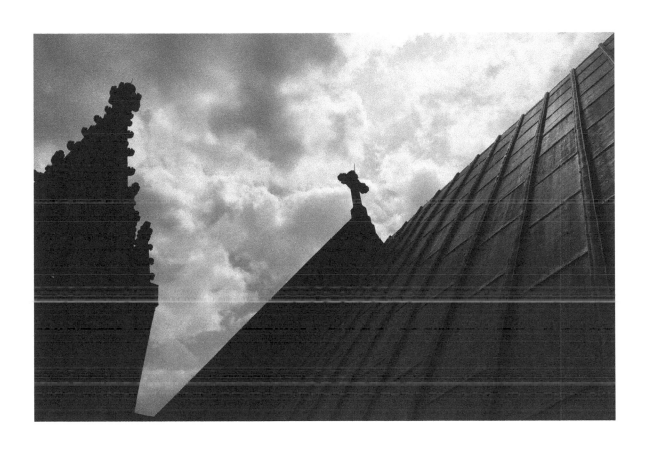

You Get Better

Kansas City, Missouri | 2020

You just keep getting better.

How do You do it?

Topping the best and finding more to top.

A fine wine with time, a long love, a deeper faith.

The relationship with You keeps getting better.

I didn't know then what I know now the song goes, the age of wisdom hopes.

To know You is to receive more.

I keep seeing more of Your beauty.

Your heavenly grace dancing for these eyes to behold.

You are a work of art.

You keep getting better.

Spirit of Hope, Kansas City's Metropolitan Community Church

Cloud Type: Altocumulus

Subtype: Altocumulus floccus

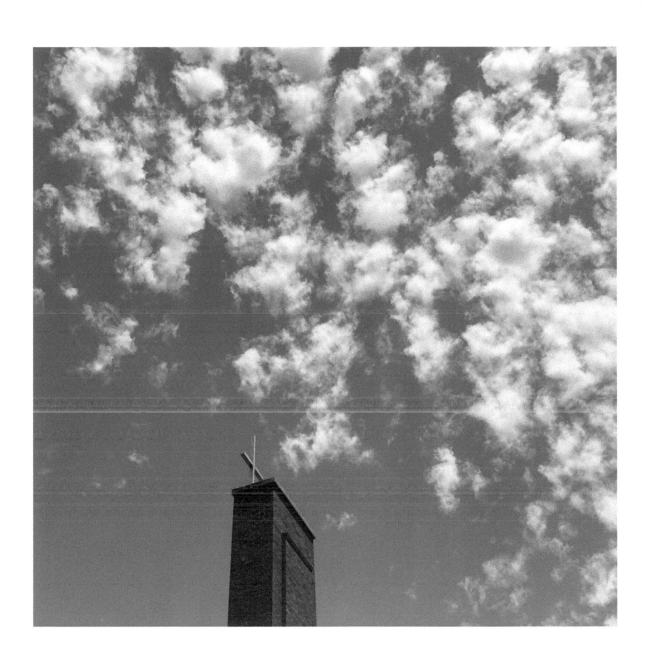

Scripture

Endurance
*"Therefore, since we are surrounded by so great a cloud of witnesses,
let us also lay aside every weight and the sin that clings so closely,
and let us run with perseverance the race that is set before us,
looking to Jesus the pioneer and perfecter of our faith."*
- Hebrews 12:1-2 NSRV

The Coming of Christ
"Look, he is coming with the clouds, and every eye will see him."
- Revelation 1:7

Transitory
*"I have swept away your offenses like a cloud, your sins like the
morning mist. Return to me, for I have redeemed you."*
-Isaiah 44:22

St. Rose Philippine Duchesne Catholic Church, Mission Woods, Kansas 2016
Cloud Type: Cumulus
Subtype: Cirrus spissatus

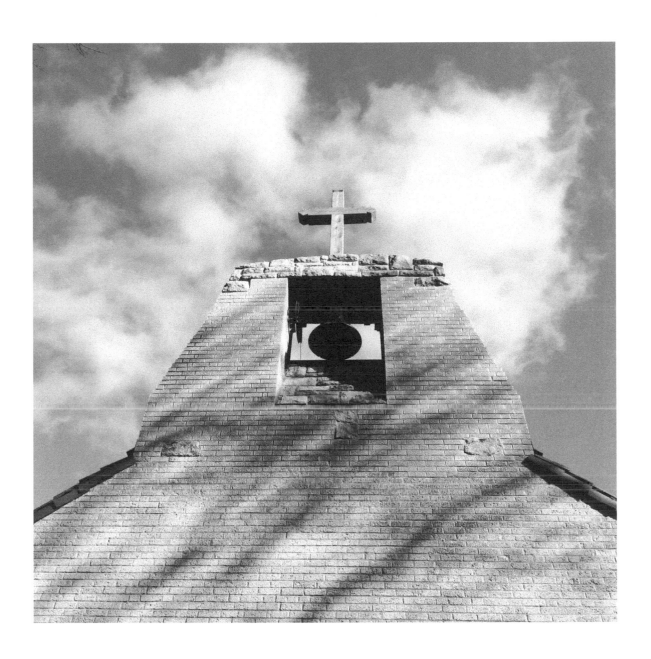

Amy Bretall

God Checks Us

God checks us. And asks: How serious are you? Will you really do what I'm asking? Will you hear Me? Will you listen? And will you do?

It's easy to hear; it's harder to act. Same for ideas being easy; it's the implementation that requires the effort.

I'm the most unlikely of disciples. But somehow my determination and discipline kept me going. A nugget was on my path. Would I follow it?

Be careful when you ask God to use you. Because it forces you to get out of your comfort zone. When you hear the call, what you used to find settling in your life, now unsettles your soul. It calls to you. Something new takes place in your heart and soul. It becomes compelling.

Compelling in the sense that it's not an option. It's more than an idea stirring within that dissipated. It lodges in your inner-being, forming a cross (for me it literally was the image of crosses in photos). You can't turn from it because it holds you in a warm embrace. Keeping the form of your current life no longer fits. Comfort now only comes when you turn towards the call. It's inside you. Somehow all the prayer and reading the Bible has transformed you into believing. It takes hold. And behold the power of faith.

As you take steps of faith, when doubt tries to distract, the scriptures you've memorized speak up in your mind. When you think you should be doing some normal type of work your energy dries up. When you take steps of faith, the slivers of small openings enter to keep you going. Even when you don't know the outcome, you are compelled to take those steps and act upon. This all happened to me.

I started to really believe in faith. As I took action to follow what God placed in my heart, and when I truly was obedient, giving up my way, surrendering it all, my trust grew. I was trusting, and knowing, that the Lord will provide. Big faith. Big dreams to glorify God. Crazy, huh? Me. Me for God. That's the team I'm on.

God Will Test

Looking back there have been significant points of time in my life where I've experienced a testing of my faith. For several, I didn't know it at the time and have realized it as I continue to grow my personal spiritual relationship. God does test. There could be more, but I've experienced four tests in my spiritual development.

Test 1: Will you do what I've given you?
Test 2: Will you use what I've gifted you?
Test 3: Will you put Me first?
Test 4: Will you be obedient to My voice?

Test 1: Will You Do What I've Given You?

Jean was mine. I didn't realize it at the time, but after I completed the mission, I knew. God knew all along it would be me, almost 22 years later to fill the gap.

You never know where you'll find your jewel. We met at my first career job out of college, at Mercantile Bank, in Springfield, Missouri, in 1995 when I was 23 and she was 68. Jean was working part-time in the human resources department after retiring in bookkeeping.

She would tell the story to others of how we met saying, "I knew she was the one" to be hired for the Human Resources Representative position. She greeted me when I interviewed and answered the phone in my follow-up call.

More than a dear friend, Jean was my adopted grandmother. When I still lived in Springfield we'd spend weekends together. Going to flea markets she'd tell me about the functionality of old kitchen tools and appliances. We'd go clothes shopping and have lunch at her house. She made the best salad from her garden vegetables. Even after I moved to Kansas City in 2000 we stayed close. I called to talk with her regularly as I did with my parents. She would join our family for Thanksgiving and Christmas and I'd visit her when I came to Springfield to see my parents.

In August, 2014 when Jean was 86 and getting ready to move from her house into assisted living I helped her go through all her clothes. She was too weak to stand, hold, and make decisions on what to keep or donate. During this visit I asked for her words of advice in life. Without hesitation her knowing reply was "Trust in the Lord, he'll take care of you." She didn't have to think about the answer, it immediately flowed.

Jean never married, nor had kids. She and her sister lived together in a small house. After her sister passed she returned to work part-time at Mercantile Bank to fill time and also because she needed the money. Jean was working in the human resources department answering phones and administrative work. This is where I met her. For 22 years we stuck.

In December 2015—16 months after Jean moved into assisted living—dementia started to appear. After a hip break she was transferred into the Memory Care unit. This is when I became her medical power of attorney and her health steadily declined. She had several second cousins, but none close enough to fill the role of a trusted confidante. She had a full family of church and work friends, but all were aging as well.

Everyday I called her and checked in with her nurses and care team. I drove frequently to Springfield from Kansas City to see how she was and ensure she was receiving good care. I helped her move from assisted living to memory care and then to the nursing home, sorting her items and making sure she had what she loved. She passed peacefully in June 2016. In the very end, Jean almost ran out of money, but didn't. The remaining money she had left, she was able to leave for her long-time church. Trust.

I found my writing voice as I wrote about my love for Jean during her period of health decline and the months and years following. Through two hip breaks, dementia, pacemaker battery replacement, and continuing urinary tract infections, I wrote about my love for her. I called her My Sweet Jean. Because she was.

It's For You To Do

I knew in my every being, that Jean was for me to do. Without question, nothing could move me from this place and priority. There wasn't another friend or close relative to fill the gap. It was for me and I was just what she needed. I'd pray, "God, let me be what Jean needs," because I didn't have experience with elder care, nursing homes, or dementia. You know what? All I needed was love. My temperament was already formed. My resolve was already there. Twenty-two years of love filled in the cracks.

Jean had said she wasn't going to have a service, but I did for her as she did for her sister and held a funeral and graveside service. Writing the obituary, selecting the songs she loved, including her favorite scripture, creating a video photo collection of her with her friends, and displaying some of her keepsakes, framed photo and awards. There were thirty people in attendance. At age 89, she was preceded by many of her friends.

A few days before Jean's funeral as I was driving to Springfield, I had a new realization.

With my hands on the wheel, I leaned forward in the car, looked up to heaven over the dashboard and said aloud to God: "You knew all along!" Close to 22 years in the making, it would be me to fill this gap. It was a role I stepped into seamlessly and maybe that's how you know it's meant for you—there is no question. It just simply, is.

I gave my best presentation delivering her eulogy. I didn't know how my random thoughts would come together. I prayed and found clarity. I received two "Amens" during delivery from a deep-voiced gentleman. Afterwards, the vocalist found me, and shared she sings at a lot of funerals, that she never met Jean, but felt like she knew her, telling me that it was the best eulogy she had ever heard. When it's made for you, it just flows.

When I interviewed at the bank 22 years prior, Jean said "I knew you were the one." She was right. Yes, I got the job. The job of taking care of Jean at the end. Best job ever. It was hard, and emotionally taxing, but also redeeming and deeply fulfilling.

During the final months of Jean's life, people in the hospital, nursing home, etc. that I'd come in contact with would comment, "Oh, you are such a blessing. What would she have done?" At the time I accepted the comments. But as I wrote about my love for Jean I realized it was the complete opposite. As my grief and sadness lifted with time, and when I could just soak and settle in my love, it became clear that caring for Jean was a blessing given to me. It was my honor. Jean is my true love story—then and now.

"Trust in the Lord with all your heart and lean not on your own understanding; in all thy ways acknowledge him and he shall direct thy paths." Proverbs 3:5-6 NIV/KJV

Test 2: Will You Use What I've Gifted You?

You know what started all of this? The photos, gallery shows, writing about faith? Prayer. For a 12-month period spanning the years 2014/2015 I prayed daily, "God, use me." I didn't hear anything for over a year; nothing tangible was received.

Then, in August of 2015, I visited my grandmother on the farm where my sister and I spent summers growing up. Talking on the phone with my mom a few days earlier she said, "You know, you might not have another chance to see your grandmother again." My grandmother was 87 at the time. She was selling the farm, the same house and place she had lived for 72 years, and was moving to North Carolina to live near my aunt. I heard the prompt so I called my grandmother and went that weekend.

Back to my roots, on the farm in rural Missouri, to visit my grandmother was the start of my photography. I took photos there to remember it, with no intent to do anything with the photos. I loved the photos, the feeling of peacefulness, of home, and the natural timeless beauty.

There is power in our elders: my adopted grandmother Jean and my blood grandmother Edna. I visited my grandmother for a weekend in August, staying in her farmhouse with no air conditioning. It was here I learned for the first time that she read the Bible and was on her seventh time reading it cover to cover. When asked what she liked about it she said, "It has a lot of great stories." Next year, as I'm reading the Bible for the first-time cover to cover, I often thought, "Grandma, you're right, there are a lot of great stories." A year after visiting my grandmother on the farm, she passed away in North Carolina. I gave the eulogy at her funeral. Four months prior I had given the eulogy at Jean's funeral.

During this extended 12-month time period of diligent prayer, I didn't notice anything externally change. But daily, a small disciplined habit within developed.

Also in 2015, in November, on a trip to Cuba I serendipitously met a young girl outside of Ernest Hemingway's estate. I turned around and there she was. We had a brief walk together and short exchange in my little bit of Spanish. While I sat on the bus to drive

back to Havana I was thinking of Jean who was age 88 at that time. I realized I had more in my heart and this little girl would be the next recipient of my affection. Returning to Kansas City, I was inspired to help. Months later, with more prayer, I had the idea of turning some of my photos, taken with my iPhone, into greeting cards as the vehicle to help.

God says, I will give you talents. Will you use them?

I'm not formally, or informally, trained in photography or writing. I graduated college with a bachelor's degree in Business with an emphasis in Human Resources and have a master's degree in HR Management. My career life has been in HR for over twenty-five years, holding professional level positions in for-profit companies, holding senior-level strategic HR management roles, and being part of executive leadership teams.

Early on in my project to turn my photos into greeting cards, I became frustrated trying to figure out the pixels, technical aspects, and numerous other details I didn't know. Talking with my Sweet Jean on the phone, I said if I didn't do this project, I realized no one else would. I shared the realization and was questioning myself, "How important is this, Amy?" knowing there wasn't another person to move it along. It was just me. The photos are in my phone library. Jean simply says to me, "I think you'll do it." No hesitation, it was a matter-of-fact statement.

Two months later I returned to the project. As I took steps of faith, the project grew from the initial idea of card gifts. It moved into framed prints, journals, and then I started writing about faith and what I was learning along the way. I started taking photos of formed crosses, but as I took steps of faith and turned deeper into prayer, I started seeing "everyday" crosses. Five years later, in 2020, I published my first book *In Plain Sight: Faith Is In The Everyday*. And where was it I saw my very first everyday cross before I even knew what I was taking a photo of? It was at my grandparent's farm in 2015.

It's been six years since I started and I still haven't taken any photography classes, read or studied the topic. I still use only my iPhone. Often people have a tendency to overcomplicate getting started. I wasn't swayed when others told me I should get a

professional camera or that I would need to take photography classes. My thought was no, I don't. This works for me.

It doesn't take a lot to start. What I like about using my phone is it's accessible; anybody can find things of beauty in their everyday. It doesn't take special equipment, a professional high-end camera, or skilled training. If it's a gift you have, use it. What you really do have to have is courage. The courage to follow your idea and the dedication to follow it.

A low-cost starting tool I utilized is community. Reach out to people and ask. Some you will know, others you will have to find. Ask, seek, knock. I implemented the biblical principle from Matthew 7:7, "Ask and it will be given to you; seek and you will find; knock and the door will be opened to you."

At the very beginning of my quest to use my photos I reached out to a very close friend with a keen eye for design. She was formally trained in the arts as well as having a professional career in design. I knew she would be honest and tell me if my photos were good or not.

When I first printed a handful of my photos to turn into greeting cards I went to a small locally owned photo shop. Unsolicited, one of the shop owners said he judges a lot of photo competitions and thought the composition of my photos were better than most he sees. That was validation. And a nice sign from God.

I reached out to a professional local photographer and asked if he would share his thoughts about my photos and any other business insights. He offered to buy some of my photos. That was validation! He also gave me some good business advice from his experience. Later he introduced me to a gallery looking for cross artwork, which was my first show at Steeple of Lights Art Gallery in 2018.

When getting started these small slivers keep you going. Months later I met with a friend to show her my small white box where I kept my photography greeting card samples. We were sitting outside on a street patio enjoying coffee and a man walking by commented on the card on top. He said, "That's a cool photo." and kept walking. I received it as a little nudge from God.

Especially in faith, and when working to glorify God, believe in the signs received. That belief only comes from taking steps of faith though. You have to start. It won't happen if you keep your idea within. It has to be shared with others.

> *"I want to remind you to stir into flame the strength and boldness that is in you."*
> *2 Timothy 1:6 TLB*

Test 3: Will You Put Me First?

The spiritual call kept knocking and made me examine where I should be. It required me to place my priority and standards of faith above comfort levels, touching all aspects of life. I was no longer able to look at my faith life with an optional viewpoint. I was in a long-term relationship living together, but not married.

As my personal relationship grew with God, this lack of marriage while living together became a problem. Enter the test. Am I going to live my faith? Even when it's hard? Or will I keep taking the easy way? How long can I justify to myself that love is enough, that the promise of marriage in the future is okay. Well, I couldn't do it any longer. You know why? Because my life had a new definition: "I take photos of crosses and write about faith." I felt like a fraud.

I wanted to honor God in my actions and my belief system included how I lived my life. It became clear why this situation bothered me, because it did not honor God. I don't have to, or need to, be married. I've been married before for six years, right out of college. As my personal relationship with God grew deeper, marriage became important to me, because faith was a priority.

My old comfort was replaced with an indispensable will to live my faith. I kept receiving messages of strength and courage when reading scripture and when listening to messages of faith. Over and over, on and on. Amy: "Strength." Amy: "Courage." In January of 2019 I moved out.

My test was presented. God asked: "Amy, will you put Me first?" I chose my faith. My God became bigger than my wants. And the relationship moved down the pecking order. Obeying God, following my faith beliefs, became my ultimate priority.

You will have to take a stand and make a choice in your faith system of life. Faith is a noun. And faith is a verb, requiring action. Sometimes the choice will be hard, or seem hard, because of love, because of money and financial arrangements, or because of what other people say.

It took me several years to figure this out—that's called being "lukewarm" in faith. I had to develop my own self-confidence of faith in order to answer the test. With faith you don't get to lean on someone else and use theirs. You can't borrow from your parents' lifetime of faith. Others can be a guide, good ones at that, but it's for you—and you alone—to develop your own faith system. Many people around you will "say" they are a man or woman of faith, but they don't live it. That was me. This was a real test.

At some point, you will have to choose. Is faith important in your life? Is it a value? What is the priority order of your faith? It's not just faith, it is your relationship with God. Where does God fit into your life? It wasn't something I could compromise anymore. My faith was newly ordered and I had to live it.

I realized if I'm serious, I couldn't be lukewarm. The question is asked: Are you with Me? Are you *really* with Me? The answer will be tested. A lukewarm Christian, someone who claims to be a follower of Jesus but lives as they are content in their own ways, will not last long. When faith is chosen, and placed as a priority, surroundings which don't fit the value system become unsettling. You—and you alone—will know. And you—and you alone—will have to act. The Bible teaches the choice to be either hot or cold in your faith, you don't get to be half-way. Revelation 3:15-16, "I know your deeds, that you are neither cold nor hot. I wish you were either one or the other! So, because you are lukewarm—neither hot nor cold—I am about to spit you out of my mouth."

Honoring God is following biblical principles. It takes faith to know. And it takes faith to follow. Once I knew, my conscience wasn't satisfied with the status quo. I found as my relationship with God grew, there is a deeper scale of faith. It's where you honor God.

My faith standard took a stand and my inner voice condemned myself. As I deepened my faith and took steps of faith, God's test opened a new window for me to view an area I wasn't measuring up. "They demonstrate that God's law is written in their hearts, for their own conscience and thoughts either accuse them or tell them they are doing right." Romans 2:15 NLT

I placed my faith in my relationship with God. Years earlier I had been praying, "Use me Lord." And then he did—I received signs of God through nature, timed and placed for me. They were a visual representation of a higher love, and I took photos of these, which led to my next test.

"Be strong and of a good courage." Joshua 1:9 KJV

Test 4: Will You Be Obedient To My Voice?

When you truly believe, your internal faith and developed spiritual relationship takes hold. It's a self-perpetuating cycle. First you believe, then you take steps of faith which brings a deeper belief, which in turn causes additional steps of faith. This strengthens your faith leading to more steps of faith. It can become the kind of faith that some people look at and don't understand. It's not "practical." It's not financially in your best interest. It's not what "other" people are doing. It's not what the material world of "more" does.

My test of obedience for what I knew God wanted me to do was creating and publishing a book compiled of the everyday crosses I'd found over the prior five years. It was May 3, 2020 I asked God for another sign of what I should do. I had over 60 photos of everyday crosses found on my walks, during prayer. Each was timed for me and delivered as a gift. On this morning, going out for a walk, I prayed, telling God I knew it was silly for me to question it, but I asked for one more sign to let me know for sure. Like all the other everyday crosses received, this one was given to me. Walking back, going a different route, down the stairs was another everyday cross, formed from twigs, laying gracefully. The message was clear, "Amy, take the next step." I hear you God. And so I did. I found a graphic designer to handle the technical aspects in InDesign with my photos and writings about faith. It was November of 2020 when I released the book, *In Plain Sight: Faith Is In The Everyday.*

I said "Yes" and trusted God for the outcome, whatever that was. For five years I had been sharing these everyday crosses with others, posting on social media. At times I'm unsure that what I write is any good. I turn to God and trust that if I'm meant to write, then God will give me the words. I'm often inspired to write what I see in the photos, which is finding the beauty in non-attractive, over-looked forms. I also write what I hear God say to me and what I've learned as I've developed my faith. This book, *Sights of Faith,* is about my deeper relationship with God.

My first book is how I saw God show up in my everyday life and how by taking steps of faith, I deepened my spiritual relationship. This second book is knowing God and growing even closer, developing a love. A true relationship takes time. And a deep relationship requires trust.

What does it take to be obedient?

Stillness
First you have to be able and open to hearing. For me, that takes stillness. It is often the small voice of faith, or a small sign of faith, that leads the way. When so much around is bigger, louder, and surrounding forces want to compete for your time, prioritizing stillness and periods of silence provides for a closer relationship with God. We need to be able to hear. As an example, when taking a walk, I don't listen to music. I like to have my senses available. I usually pray, think about my next steps, the desires of my heart, and in that setting, I am swayed to walk a certain way, a certain time and see new things. All the little nudges, a small knowing. Listen to the voice.

Patience and Perseverance
It took five years to be ready, to have enough photos, and to complete *In Plain Sight*. You have to do steps 1, 2, and 3 before you can get to steps 4, 5, and 6. You can't get to the next phase until completing the first small steps. You don't get to jump ahead. It takes work. And then, with patience and perseverance, all of a sudden it's step 132. Everything starts small, like the mustard seed of faith. Will you wait for it? Will you work for it? Will you be obedient to it?

Prayer
Prayer is a game changer. It hones your heart and with a willing spirit prayer leads you. The question is: Will you follow?

While prayer is free, it is going to take something. Your time, some discipline, and dedication. Like any really good relationship, you have to spend time with another—listening, giving attention, learning about, sharing, not being distracted, taking time, and caring. If you can't fit in God because you are so busy with what you want to do, you are still following your own way. But you know what? God is patient and will wait for you. God knows your heart.

Overcome Doubt
Doubt is the devil. While I'm finishing the outline for my first book, the voice of doubt pops up, "Amy, come on, do you think this really is anything?" It was a second of doubt that brought me pause. I answered, "Well, yes I do think this is something." The phrase that popped in my head was, "What if I fail." And the wonderful following line, "Oh Darling, what if you fly!" The voice of doubt returned, asking, "Really? It's just photos in your phone." It again brought

me pause and I thought about how many signs God has given me, speaking to me. Psalms 37:4 came to mind, "Take delight in the Lord and he will give you the desires of your heart."

While I'm organizing this second book, on a roll, the voice of doubt says, "Come on Amy, really?" Like the Devil did in Genesis 3:1, using the word 'really' has been a repeated strategy. "Now the serpent was more crafty than any of the wild animals the Lord God had made. He said to the woman, "Did God *really* say, 'You must not eat from any tree in the garden'?" Doubt tries to stop you.

When I told a good friend I was doing a book she said, "You aren't ready for a book." My reply, "Yes I am." I didn't let the negative comment take my idea. You know why? Other people don't know what you have. Secondly, it's not been given to someone else; it's for me to do. Don't let someone take the bubbling up beginning of your idea. Don't let someone's negativity stop your momentum. Don't let what someone else doesn't see, limit what you do see. Keeping strong in your faith will help you stay strong in your idea.

Trust God

When I finished *In Plain Sight: Faith Is In The Everyday,* a teenager friend was reading this book and asked if writing it was hard. I found it to be an interesting question. The many steps of putting together something new, writing, bringing all the pieces together took effort. But it was not hard. What was hard, at times, was overcoming doubt and completely trusting God. Faith kept me strong.

Jean helped me trust God and deepen my personal faith. During times of personal challenges as an adult I turned to Jean's words of advice often. I memorized Proverbs 3:5-6 which closely mirrored her words of advice. "Trust in the Lord with all your heart and lean not on your own understanding. In all thy ways acknowledge him and he shall direct your steps." Because of how Jean and I were blended together I'm able to trust God. Because of Jean, I trust in my next twenty-two years.

My test of obedience was trusting God. I knew God was asking me to do the book because the signs kept coming. It was *In Plain Sight.* Completing the step of faith with the first book brought me this second book. And I will, God.

"Set your minds on things above, not on earthly things." Colossians 3:2

Story Behind The Cross

Cookeville, Tennessee | 2021

Lead Pastor Steve Tiebout wanted to build this cross to brag on how big God is. Land right off interstate 40, 24 acres was gifted, as only God can bring people together. Working with the designer, the church family did much of the work on the 110-foot-tall metal frame. Their prayers were answered when a crane owner happened to come through the area. It was set in concrete and raised in 2006. The cross, situated on a hill as a prayer mountain and prayer wall, with a paved walking trail, is a place people can connect with God and realize how big God is.

The River Community Church, non-denominational

Cloud Type: Cumulus

Subtype: Cumulus humulis

Let Your Light Shine

Williston, North Dakota | 2019

Rarely seen and rarely known, you just glow. From within, in your own right, unique in your coloring and shape.

You may not always see or feel My presence, but I Am here. Even when the storm clouds stay too long, I will wash you clean.

There is hope in a clear blue sky, small wisps of Me, dotted white clouds, or My way of message in striking big boldness you can't miss.

Trust Me.

Let your light shine.

First Lutheran Church
Cloud Type: Cirrus
Subtype: Cirrus floccus radiatus

Amy Bretall

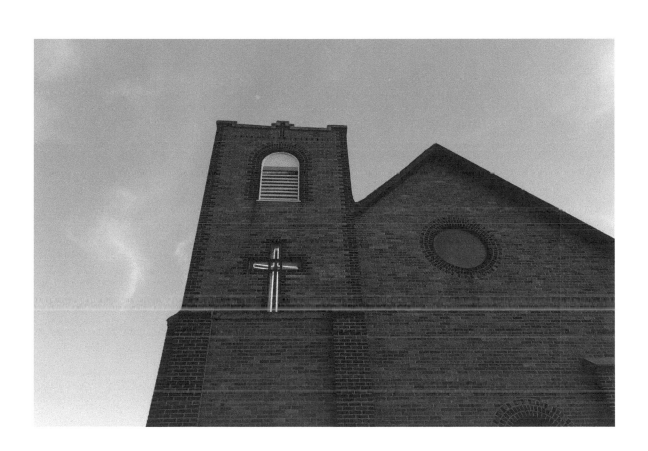

I'm Closer Than You Think

Cookeville, Tennessee | 2021

I'm closer than you think.

Right here. Right now.

All it takes is for you to believe in Me.

I'm here every day waiting for you.

Surrounding you with My love.

And when you let Me in, I'm there. You'll see.

I'm close.

Right here. Right now.

The River Community Church, non-denominational
Cloud Type: Cirrus

And Then You Said

Clarksburg, Missouri | 2020

Behold.

I'm all around My one.

Don't worry.

Look up and see Me.

Goodness surrounds.

Get to a place where you're cleared to see.

Find a place and be.

You are...with Me

Cloud Type: Altocumulus

Subtype: Altocumulus floccus

Amy Bretall

Row Your Boat

Belton, Missouri | 2019

Row your boat. Row your own boat.

You will have to do it alone. There will be times you have to go it alone.

Ideas are easy, it's the execution that takes effort.

Those first steps are the hardest and not everyone will be onboard. No knock against them, but the charted course you see, isn't something others will.

It's in you for a reason, so don't wait for someone to throw a life line.

People aren't going to row your idea. You will receive some uplifting breezes and wind on your back from community.

But make no mistake, you are the rower—the effort and energy to produce momentum. The long haul is yours.

Divert the rocky water of doubt and chopping pessimism.

Hold onto your life preserver of faith.

Belton Assembly of God
Cloud Type: Altocumulus (top), Cumulus (bottom)
Subtype: Altocumulus floccus, Cumulus humulis

Standing Before

Lebanon, Missouri | 2019

Here I am.

Standing alone and standing before.

In my time of taking up space on this earth, I ask, "Lord, did I do enough for You? Was it good enough?"

There's a turn in my mind, one that doesn't always go with the road I wanted to drive. The plan changed.

My mind repeats, "What else can I do for You today?"

Your plans become my plans and I've forgotten what course I was on.

When obedience became a priority the obstacle course was removed. The road opened.

At some point, standing alone and standing before, I will be awaiting the answer "Lord, did I do enough for You?"

Sleeper United Methodist Church
Cloud Type: Stratocumulus
Subtype: Stratocumulus floccus

Amy Bretall

Lord, I Will

Springfield, Missouri | 2020

Lord, I will.

Listen to what You place in my head.

The passing thought. The nudge. When I want to ask: Why now? What do you mean?

It's being obedient in the small things we walk in faith.

Listening requires an ability to hear Your quiet voice, especially in our world of disruption.

It takes silence to hear, receive, accept, and do.

Hearing. Acknowledge the message.

Receiving. Discern the meaning. It's often a simple inner knowing.

Accepting. Even when I want to question it, doubt it, push it away, I've learned to trust. Don't discount it, because the message will return.

Doing. Take action.

Hear, receive, accept, and do.

Lord, I will.

Southland Christian Church
Cloud Type: Stratocumulus
Subtype: Stratocumulus floccus

Amy Bretall

About Clouds

Clouds are classified according to their appearance (texture) and height above the ground. The World Meteorological Organization classifies clouds into ten main groups, called genera. Each observed cloud is a member of one—and only one—genus, more commonly referred to as type. Most cloud types are subdivided into species (sub-type) due to peculiarities in the shape of clouds and differences in their internal structure.

Clouds are generally encountered over a range of altitudes from sea level to the top of the lowest layer of the Earth's atmosphere, called troposphere. This region is vertically divided into three levels: high, middle and low. Each level is defined by the range of heights at which clouds of certain genera occur most frequently.

Five cloud types translated from Latin are: Cirro meaning 'curl', Cumulo meaning 'heap', Strato meaning 'layer', Nimbo meaning 'rain' and Alto meaning 'high'.

Cloud Types

Three High Level Clouds:

Cirrus Thin, feathery, or wispy with silky shimmer, made of ice crystals.
Cirrocumulus - Thin, flakey, pure white field, small grains, lumpy, ripples, cumulus patches.
Cirrostratus - Thin, transparent, pale, veil-like, layer capable of producing a halo, casts shadow.

Three Middle Level Clouds:

Altocumulus - White/grey patches arranged in groups, rolls, or layers.
Altostratus - Featureless, grey layer cloud capable of masking the sun.
Nimbostratus - Dark and featureless precipitation layer cloud responsible for rain and snow.

Four Low Level Clouds:

Stratus - Gray, uniform and flat, capable of ground contact, layered, develop horizontally.

Cumulus - Isolated fluffy heaps of clouds with sharp outlines, cotton-like appearance, resembles a cauliflower, develop vertically.

Stratocumulus - Thicker, grey or whitish, and somewhat conjoined heaps of clouds, rolls or bundle, layer of cloud clumps, almost always has dark parts. Hybrid of layered stratus and cellular cumulus.

Cumulonimbus - Heavy, dense, dark-based storm cloud capable of impressive vertical growth, thunderstorm producing.

Cloud Sub-Types

Cloud sub-types/species are used to describe the shape and structure of clouds. Sub-types matching photos identified in this book have been included here.

castellanus - rising towers, turrets
congestus - towering, bulging upper, taller than it is wider
fibratus - fiberlike, hairlike
floccus - puffy, ragged tufts
fractus - ragged, broken up
humilis - flattened, wider than it is tall, fair-weather cumulus
spissatus - packed tightly, dense
stratiformis - horizontal, layer-life form

Other clouds identification terms noted in the photos are: **duplicatus**—multi-layered; **intortus**—intertwined, entailed; **opacus**—opaque, masks the sun; **radiatus**—parallel bands and strips; **undulatus**—wavelike, undulating.

Nephology: Greek word nephos for 'cloud' is the study of clouds and cloud formation.

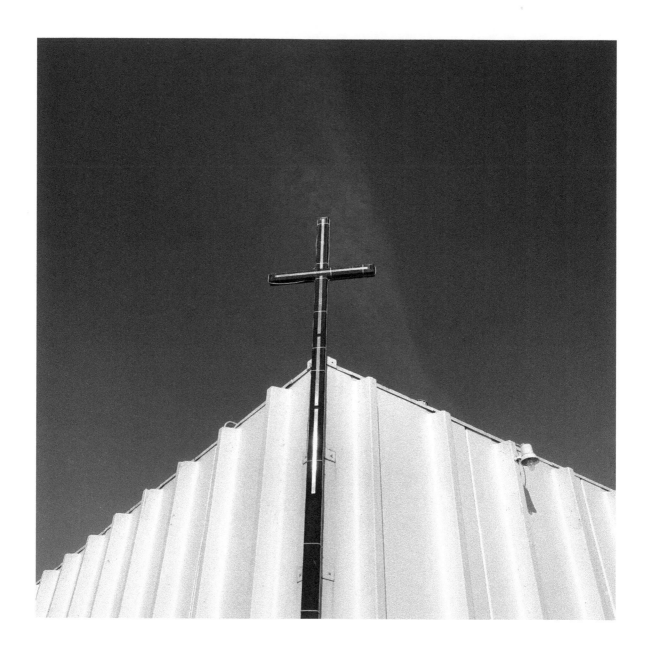

Saint Matthew African Methodist Episcopal Zion Church, Kansas City, 2018
Cloud: Contrail: narrow line-shaped vapor trail produced as aircraft exhaust
condenses in cold air at high altitudes.

Amy Bretall

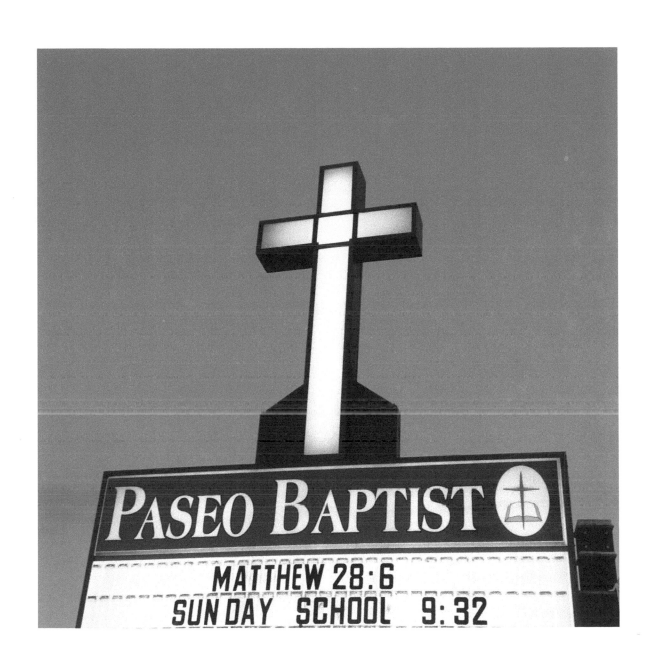

Paseo Baptist Church, Kansas City, Missouri 2019
Cloud Type: Cirrus

And The Clouds Say...

Kansas City, Missouri | 2021

"I'm opening a way."

I've passed this church for many years but never stopped to take a photo. It wasn't the right timing, the sky wasn't there.

Patience and timing.

A simple analogy. Prepare. Know. And be ready. Because those cloud formations shift, and if you don't take the shot when it's ready, it most likely won't be there later. Sometimes the clouds dance above for hours, providing ample opportunity. But most days the changing skyscape moves quickly, giving only minutes. Passing seconds change the look.

See it. Know it. And take the opening. In life, that is the challenge. When to pause and be patience and when to step up and take it!

And the clouds say "I'm opening a way. See the abundance in Me."

Colonial Presbyterian Church
Cloud Type: Stratocumulus
Subtype: Stratocumulus floccus

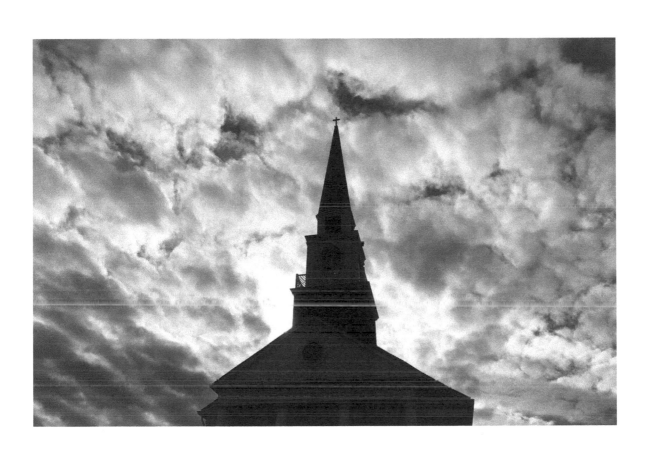

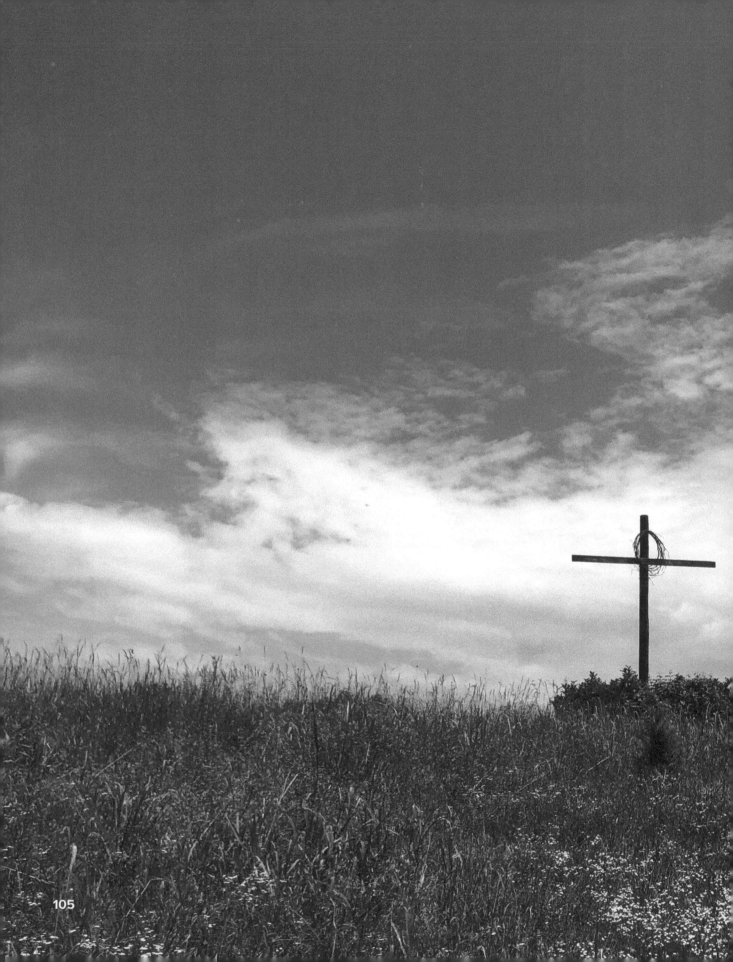

Faithful Within

Cookville, Missouri | 2021

Be faithful to what's in your heart.

There's a certain sweetness in not knowing. In taking steps in faith, without a known end point.

Oh, the uncertainty. Well, that is called walking in faith, not by seeing what's ahead, or knowing if it will be successful.

Embrace it. And get on with it. Do what you need to be doing because the "It" will keep calling. You don't get to choose.

Be strong and of good courage. There will be times you wish you were sitting "over there." But you know that won't work. You've tried it before. The pull is too great. Your inner spirit pulls you "here," to work on "It."

The "It" being what's right in front of you. The "It" being what's in your heart. You know the "It!"

Get on your path. The call is yours.

Photo on prior pages 105/106: Centertown, Missouri, 2021
Cloud Type: Cirrocumulus
Subtype: Cirrocumulus stratiformis

The River Community Church
Cloud Type: Cirrus (top), Cumulus (bottom)
Subtype: Cirrocumulus undulatus, Cumulus congestus

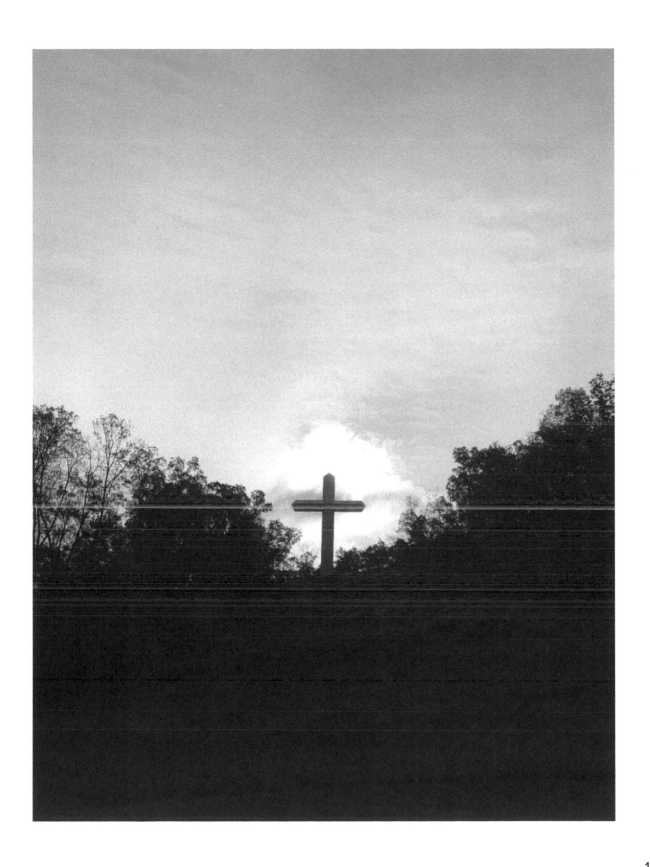

Cloud Scriptures

Genesis 9:13-14

"I have set my rainbow in the clouds, and it will be the sign of the covenant between me and the earth. Whenever I bring clouds over the earth and the rainbow appears in the clouds,"

Exodus 13:21-22

"By day the Lord went ahead of them in a pillar of cloud to guide them on their way and by night in a pillar of fire to give them light, so that they could travel by day or night. Neither the pillar of cloud by day nor the pillar of fire by night left its place in front of the people."

Exodus 14:24

"At the morning watch, the Lord looked down on the army of the Egyptians through the pillar of fire and cloud and brought the army of the Egyptians into confusion."

Exodus 16:10

"While Aaron was speaking to the whole Israelite community, they looked toward the desert, and there was the glory of the Lord appearing in the cloud."

Exodus 19:9

"The Lord said to Moses, "I am going to come to you in a dense cloud, so that the people will hear me speaking with you and will always put their trust in you." Then Moses told the Lord what the people had said."

Exodus 19:16

"On the morning of the third day there was thunder and lightning, with a thick cloud over the mountain, and a very loud trumpet blast. Everyone in the camp trembled."

Exodus 24:15-18

"When Moses went up on the mountain, the cloud covered it, and the glory of the Lord settled on Mount Sinai. For six days the cloud covered the mountain, and on the seventh day the Lord called to Moses from within the cloud. To the Israelites the glory of the Lord looked like a consuming fire on top of the mountain. Then Moses entered the cloud as he went on up the mountain. And he stayed on the mountain forty days and forty nights."

Exodus 33:9-10

"As Moses went into the tent, the pillar of cloud would come down and stay at the entrance, while the Lord spoke with Moses. Whenever the people saw the pillar of cloud standing at the entrance to the tent, they all stood and worshiped, each at the entrance to their tent."

Exodus 40:34-38

"Then the cloud covered the tent of meeting, and the glory of the Lord filled the tabernacle. Moses could not enter the tent of meeting because the cloud had settled on it, and the glory of the Lord filled the tabernacle. In all the travels of the Israelites, whenever the cloud lifted from above the tabernacle, they would set out; but if the cloud did not lift, they did not set out—until the day it lifted. So the cloud of the Lord was over the tabernacle by day, and fire was in the cloud by night, in the sight of all the Israelites during all their travels."

Leviticus 16:2

"The Lord said to Moses: "Tell your brother Aaron that he is not to come whenever he chooses into the Most Holy Place behind the curtain in front of the atonement cover on the ark, or else he will die. For I will appear in the cloud over the atonement cover."

Numbers 9:15-23

"On the day the tabernacle, the tent of the covenant law, was set up, the cloud covered it. From evening till morning the cloud above the tabernacle looked like fire. That is how it continued to be; the cloud covered it, and at night it looked like fire. Whenever the cloud lifted from above the tent, the Israelites set out; wherever the cloud settled, the Israelites encamped. At the Lord's command the Israelites set out, and at his command they encamped. As long as the cloud stayed over the tabernacle, they remained in camp. When the cloud remained over the tabernacle a long time, the Israelites obeyed the Lord's order and did not set out. Sometimes the cloud was over the tabernacle only a few days; at the Lord's command they would encamp, and then at his command they would set out. Sometimes the cloud stayed only from evening till morning, and when it lifted in the morning, they set out. Whether by day or by night, whenever the cloud lifted, they set out. Whether the cloud stayed over the tabernacle for two days or a month or a year, the Israelites would remain in camp and not set out; but when it lifted, they would set out. At the Lord's command they encamped, and at the Lord's command they set out. They obeyed the Lord's order, in accordance with his command through Moses."

Numbers 11:25

"Then the Lord came down in the cloud and spoke with him, and he took some of the power of the Spirit that was on him and put it on the seventy elders. When the Spirit rested on them, they prophesied—but did not do so again."

Numbers 12:5

"Then the Lord came down in a pillar of cloud; he stood at the entrance to the tent and summoned Aaron and Miriam. When the two of them stepped forward,"

Deuteronomy 33:26

"There is none like the God of Jeshurun, who rides the heavens to your aid, and the clouds in His majesty."

2 Samuel 23:4

"He is like the light of morning at sunrise on a cloudless morning, like the brightness after rain that brings grass from the earth.' "

1 Kings 8:10-12

"When the priests withdrew from the Holy Place, the cloud filled the temple of the Lord. And the priests could not perform their service because of the cloud, for the glory of the Lord filled his temple. Then Solomon said, "The Lord has said that he would dwell in a dark cloud;"

1 Kings 18:44-45

"The seventh time the servant reported, 'A cloud as small as a man's hand is rising from the sea." So Elijah said, "Go and tell Ahab, 'Hitch up your chariot and go down before the rain stops you.' " Meanwhile, the sky grew black with clouds, the wind rose, a heavy rain started falling and Ahab rode off to Jezreel."

2 Chronicles 5:13-14

"The trumpeters and musicians joined in unison to give praise and thanks to the Lord. Accompanied by trumpets, cymbals and other instruments, the singers raised their voices in praise to the Lord and sang: "He is good; his love endures forever." Then the temple of the Lord was filled with the cloud, 14: and the priests could not perform their service because of the cloud, for the glory of the Lord filled the temple of God."

Job 22:14

"Thick clouds veil him, so he does not see us as he goes about in the vaulted heavens."

Job 26:8

"He wraps up the waters in his clouds, yet the clouds do not burst under their weight."

Job 30:15

"Terrors overwhelm me; my dignity is driven away as by the wind, my safety vanishes like a cloud."

Job 35:5

"Look up at the heavens and see; gaze at the clouds so high above you."

Job 37:15-16

"Do you know how God controls the clouds and makes his lightning flash? Do you know how the clouds hang poised, those wonders of him who has perfect knowledge?"

Job 38:9

"when I made the clouds its garment and wrapped it in thick darkness,"

Job 38:34

"Can you raise your voice to the clouds and cover yourself with a flood of water?"

Job 38:37

"Who has the wisdom to count the clouds? Who can tip over the water jars of the heavens"

Psalm 18:9

"He parted the heavens and came down; dark clouds were under his feet."

Psalm 18:11

"He made darkness his covering, his canopy around him— the dark rain clouds of the sky. Out of the brightness of his presence clouds advanced, with hailstones and bolts of lightning."

Psalm 57:10 KJV

"For thy mercy is great unto the heavens, and thy truth unto the clouds."

Psalm 78:23 KJV

"Though he had commanded the clouds from above, and opened the doors of heaven,"

Psalm 97:2

"Clouds and thick darkness surround him; righteousness and justice are the foundation of his throne."

Psalm 104:3

"and lays the beams of his upper chambers on their waters. He makes the clouds his chariot and rides on the wings of the wind."

Psalm 105:39

"He spread a cloud for a covering, and a fire to give light at night."

Psalm 135:7

"He makes clouds rise from the ends of the earth; he sends lightning with the rain and brings out the wind from his storehouses."

Psalm 148:8

"lightning and hail, snow and clouds, stormy winds that do his bidding,"

Psalm 147:8

"He covers the sky with clouds; he supplies the earth with rain and makes grass grow on the hills."

Proverbs 16:15

"When a king's face brightens, it means life; his favor is like a rain cloud in spring."

Proverbs 25:14

"Like clouds and wind without rain is one who boasts of gifts never given."

Ecclesiastes 11:4

"Whoever watches the wind will not plant; whoever looks at the clouds will not reap."

Ecclesiastes 12:2

"before the sun and the light and the moon and the stars grow dark, and the clouds return after the rain;"

Isaiah 14:14

"I will ascend above the tops of the clouds; I will make myself like the Most High."

Isaiah 25:5

"and like the heat of the desert. You silence the uproar of foreigners; as heat is reduced by the shadow of a cloud, so the song of the ruthless is stilled."

Isaiah 44:22

"I have swept away your offenses like a cloud, your sins like the morning mist. Return to me, for I have redeemed you."

Isaiah 45:8

"You heavens above, rain down my righteousness; let the clouds shower it down. Let the earth open wide, let salvation spring up, let righteousness flourish with it; I, the Lord, have created it."

Lamentations 3:44

"You have covered yourself with a cloud so that no prayer can get through."

Ezekiel 1:28

"Like the appearance of a rainbow in the clouds on a rainy day, so was the radiance around him. This was the appearance of the likeness of the glory of the Lord. When I saw it, I fell facedown, and I heard the voice of one speaking."

Ezekiel 30:3

"For the day is near, the day of the Lord is near— a day of clouds, a time of doom for the nations."

Hosea 6:4 KJV

"For the day is near, even the day of the Lord is near, a cloudy day; it shall be the time of the heathen."

Zephaniah 1:15

"That day will be a day of wrath— a day of distress and anguish, a day of trouble and ruin, a day of darkness and gloom, a day of clouds and blackness—"

Matthew 17: 5

"While he was still speaking, a bright cloud covered them, and a voice from the cloud said, "This is my Son, whom I love; with him I am well pleased. Listen to him!"

Matthew 24:30

"Then will appear the sign of the Son of Man in heaven. And then all the peoples of the earth will mourn when they see the Son of Man coming on the clouds of heaven, with power and great glory."

Mark 13:26

"At that time people will see the Son of Man coming in clouds with great power and glory."

Mark 14:62

"I am," said Jesus. "And you will see the Son of Man sitting at the right hand of the Mighty One and coming on the clouds of heaven."

Luke 12:54

And He was also saying to the crowds, "When you see a cloud rising in the west, immediately you say, 'A shower is coming,' and so it turns out.

Luke 21:27

"At that time they will see the Son of Man coming in a cloud with power and great glory."

Acts 1:9

"After he said this, he was taken up before their very eyes, and a cloud hid him from their sight."

1 Corinthians 10:1-2

"For I do not want you to be ignorant of the fact, brothers and sisters, that our ancestors were all under the cloud and that they all passed through the sea. They were all baptized into Moses in the cloud and in the sea."

1 Thessalonians 4:17

"After that, we who are still alive and are left will be caught up together with them in the clouds to meet the Lord in the air. And so we will be with the Lord forever."

Hebrews 12:1

"Therefore, since we are surrounded by such a great cloud of witnesses, let us throw off everything that hinders and the sin that so easily entangles. And let us run with perseverance the race marked out for us,"

Jude 1:12

"'These people are blemishes at your love feasts, eating with you without the slightest qualm—shepherds who feed only themselves. They are clouds without rain, blown along by the wind; autumn trees, without fruit and uprooted—twice dead."

Revelation 1:7

"Look, he is coming with the clouds, and every eye will see him."

Revelation 14:14

"I looked, and there before me was a white cloud, and seated on the cloud was one like a son of man with a crown of gold on his head and a sharp sickle in his hand."

Revelation 14:16

"So he who was seated on the cloud swung his sickle over the earth, and the earth was harvested."

Bible verses here, and throughout the book, are NIV unless otherwise noted.

Acknowledgements

Aphrodite Platko. Thank you for helping me select the cover image and order the photos of this book, laying out all the printed pages on the floor and your expert eye orchestrating the best flow.

I'm not a Biblical scholar; this is my humble attempt to synthesize scriptures and provide a high-level overview for some of the meanings of clouds. I take full responsibility for any and all oversights, errors, and omissions. In addition to my own research of cloud scriptures I also found helpful resources at Biblehub.com and *Matthew Henry's Concise Commentary*.

Chad Horton and Cliff & Martha Rawley. Chad, a pastor, provided further scripture interpretation and several back stories for deeper meaning. Cliff & Martha gave time and consideration to the symbolism by providing word "nuggets." Cliff has a doctorate in Theology and professional career as a minister and chaplain. Both Chad and Cliff pointed my attention to the significance and meaning of 1 Kings 18.

Wes Peery, Meterologist. The first time I spoke to Wes, I didn't want any confusion about my novice weather acumen and told him my cloud knowledge was limited to what I remembered learning in 5th grade science class. I knew the names of three clouds—cirrus, cumulonimbus and stratus. Wes kindly said, "Well, there really are just three main clouds types and those are the three." I'm thankful for Wes's expertise and openness to share his insights about clouds, air movements, jet streams, and the weather. A deep thanks for taking time to identify and name each of the clouds in the book. Wes provided not just the main type of cloud, but went deeper to find the subtype, which took more time than anticipated. He said if I was doing a book on clouds, then he thought it should be specific to the full naming structure. Thanks to Wes, this book has an added angle of nephology, the study of clouds, providing learning for all ages.

I found very helpful and educational these several cloud resources, provided by Wes: WhatsthisCloud.com, and CloudAtlas.wmo (World Meteorological Organization), each provided an abundance of information. In all the years I've looked up and

Amy Bretall

admired cloud formations, I never took the step to learn more. This was the time. I also referenced Weather.gov, using these three sources to provide a high-level cloud overview while supplementing the identified cloud types named in the photos. If you are intrigued to know more, these resources are a good start.

Bill and Judy Bretall. To my Father and Mother, for always listening to my ideas, asking for updates, and most importantly their enduring love.

Also by Amy Bretall

"An incredible read!
A fusion of graceful imagery combined with introspective text, In Plain Sight takes readers on a journey brimming with belief, hope, and faith. The cross serves as the book's central character, taking shape in sunsets, shadows, sidewalks, and even stucco. Through chance encounters, we are reminded that when viewed through the proper lens nothing is mundane – even the little things in life can be extraordinary." Chelan David

"Amy's writing matches her visual style; authentic and inspirational." Rev. Michael Turner

"Beautiful and mesmerizing!
I absolutely loved all of the beautiful pictures and amazing inspirations throughout this book. The delicate simplicity of everyday crosses throughout Amy's life are so powerful. This is a great book for anyone of any age!" Jennifer Matney

*"**Inspiring work!** I was recently gifted this lovely book of inspiring photography & meaningful, calming dialogue. It so beautifully illustrated that the often overlooked, simple things of life can offer great healing for one's weary spirit."* Linda Harms

"Her writing gave me the ability to see what has always been right in front of me." Jim Baremore

Refreshing Perspective and a Perfect Gift

"We got our personal copy of Amy's book and couldn't put it down. Well, we put it down only to keep picking it back up again - and again - and again. We enjoyed this so much we immediately purchased another copy to give as a gift. Thanks, Amy, for following your heart and creating something beautiful to touch our hearts!" Steven Iwerson

An Exceptional Devotional Book of Imagery and Inspiration

"In Plain Sight" teaches us to see the sacred in the ordinary through Ms. Bretall's extraordinary photos of crosses. Bretall's inspirational words and photos will encourage the reader to look more closely at their own environment and examine their own life to discover God in plain sight." Shirley Gilmore

Wow! What a unique perspective of imagery and faith!

"A great book for men to get in touch in touch with God. We purchased this book to bring a new perspective of both faith and imagery into our household and it exceeded our expectations. The author takes us on a journey through her camera lens which opened our eyes to faith being everywhere, and in some cases the most improbable places." Kelvin Simmons

Beautiful and Meaningful Book!

"Gorgeous book. Not only are the pictures beautiful, but the author's words are authentic, encouraging, and inspiring. I gave this book as a gift and it was a huge hit. Unexpected upside? I now see crosses EVERYWHERE and it makes me smile and give thanks every time. What's not to like?" Lynn Price

Amy Bretall

About the Author

What started as a way to remember her love of rural America and her grandparent's farm morphed into Amy Bretall taking photos of crosses as she further developed her faith in her mid-forties. Amy's faith deepened when realizing God's blending beauty while taking care of Sweet Jean, her adopted grandmother, during her final years of life. The power of Amy's prayers unfolded as she began seeing patterns of faith appear in her daily activities by finding "everyday" crosses.

Born and raised in Missouri, Amy resides in Kansas City, Missouri. She has a twenty-plus year career in human resources, where she held various senior-level management positions. Amy's foray into photography began by taking photos with her phone at her grandparent's mid-Missouri farm in 2015, as a way to remember the things she found beautiful.

Amy speaks to churches, organizations and groups of all ages about her faith, photography, and books to inspire faith. Placing God first in life, Amy believes if she's meant to write, then He will give her the words. This is book two.

LiveBreatheAlive.com
Follow on Instagram @livebreathealive

CPSIA information can be obtained
at www.ICGtesting.com
Printed in the USA
BVHW061036291121
622781BV00010B/418